Alfredo Jaar
Studies on Happiness

by
Edward A. Vazquez

Afterall Books ONE WORK

Alfredo Jaar:
Studies on Happiness
by Edward A. Vazquez

First published in 2023
by Afterall Books

ONE WORK SERIES EDITORS
Elisa Adami
Wing Chan
Mark Lewis

MANAGING EDITOR
Elisa Adami

ASSISTANT EDITOR
Wing Chan

COPY EDITOR
Deirdre O'Dwyer

DESIGN
Emily Schofield

Printed and bound by
die Keure, Belgium

The One Work series is printed
on FSC-certified papers

ISBN 978-1-84638-259-8

Distributed by
The MIT Press
Cambridge, Massachusetts and London
www.mitpress.mit.edu

AFTERALL
Central Saint Martins
Granary Building
1 Granary Square
London N1C 4AA
www.afterall.org

Afterall is a Research Centre of
University of the Arts London and
was founded in 1998 by Charles Esche
and Mark Lewis.

DIRECTOR
Mark Lewis

ASSOCIATE DIRECTORS
Chloe Ting
Adeena Mey

PROJECT COORDINATOR
Camille Crichlow

ual: central saint martins

ARTS COUNCIL ENGLAND
Supported using public funding by

Graham Foundation

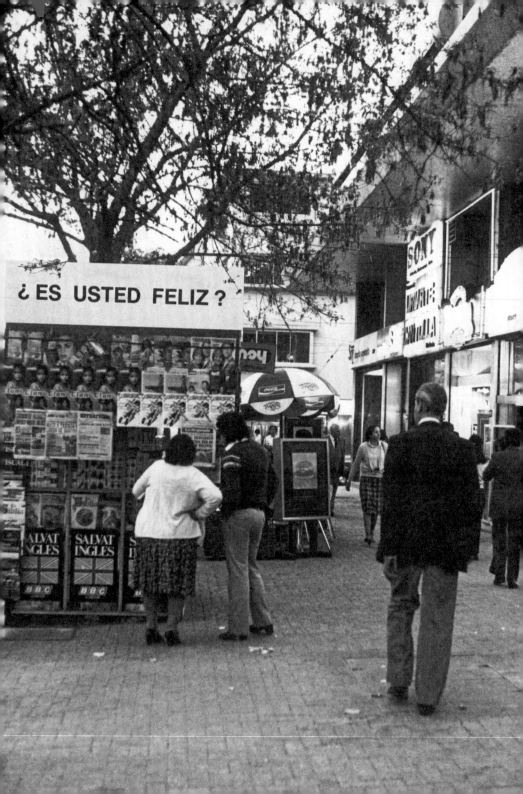

Cover and final page:
Alfredo Jaar, *Public Interventions (Studies on Happiness, 1979–81)*, 1981, photograph

Each book in the One Work series presents a single work of art considered in detail by a single author. The focus of the series is on contemporary art and its aim is to provoke debate about significant moments in art's recent development.

Over the course of more than one hundred books, important works will be presented in a meticulous and generous manner by writers who believe passionately in the originality and significance of the works about which they have chosen to write. Each book contains a comprehensive and detailed formal description of the work, followed by a critical mapping of the aesthetic and cultural context in which it was made and that it has gone on to shape. The changing presentation and reception of the work throughout its existence is also discussed, and each writer stakes a claim on the influence 'their' work has on the making and understanding of other works of art.

The books insist that a single contemporary work of art (in all of its different manifestations), through a unique and radical aesthetic articulation or invention, can affect our understanding of art in general. More than that, these books suggest that a single work of art can literally transform, however modestly, the way we look at and understand the world. In this sense, the One Work series, while by no means exhaustive, will eventually become a veritable library of works of art that have made a difference.

CONTENTS

ACKNOWLEDGEMENTS

This book would not have been possible without Alfredo Jaar's support. From our first meeting, his encouragement has been unwavering. If the notes to this text refer to many phone calls, studio visits, Zoom conversations and email exchanges, they stand as a record of Alfredo's generosity and commitment to the project. Thank you. In his studio, I thank Pablo Montealegre for help in the early stages of my research and Daqi Fang and Daniel Felix for assistance near the end. At Afterall, Elisa Adami and Wing Chan have been a pleasure to work with; what follows is evidence of their editorial attention and care.

I was fortunate to begin my research and writing — even as I did not yet understand its final form, and prior the travel constraints of the Covid-19 pandemic, which would narrow its scope — at the Center for Advanced Study in the Visual Arts at the National Gallery of Art in Washington DC, where I was William C. Seitz Senior Fellow in 2019–20. For the collegial and focussed atmosphere, I owe my deepest thanks to Elizabeth Cropper, Peter Lukehart, Therese O'Malley and Helen Tangires, as well as Caroline Marsh, Annie Miller, Jen Rokoski and the rest of the Center's staff. Jeffrey Hamburger, Carolina Mangone, Julia Oswald, Libby Otto, James Pilgrim, Miriam Said, Michelle Smiley and Ittai Weinryb were always there for criticism and conversation, academic and otherwise; Steffen Siegel and Steven Nelson even more so. It was also a pleasure to share a hall with Harry Cooper, Molly Donovan, James Meyer and Paige Rozanski. This work and writing was also supported by a research fellowship from the Graham Foundation for Advanced Studies in the Fine Arts, and I thank James Pike for his help and flexibility.

At Middlebury College, Amy Morsman, in her capacity as interim Dean for Faculty Development and Research, and Andi Lloyd, in her role as Dean of the Faculty, found ways to support my work, as has Jim Ralph, Dean for Faculty Development and Research. My thanks to Mark Williams and Charlotte Tate, who invited me to present aspects of this work on campus. My colleagues in the Department of the History of Art and Architecture have been constant sources of encouragement, and I especially thank Eliza Garrison and Katy Smith Abbott, who have been helpful in more ways than they know. Michaela Davico, it must be said, is a lifesaver in all things.

Much of what follows draws on a range of scarce, limited-run historical materials. Those who have digitised important documents at the Centro de Documentación de las Artes Visuales del Centro Nacional de Arte Contemporáneo (CEDOC/CNAC) — where many of the primary sources used in this book can be found — have my sincere thanks, as do the staff of the digital archives of the Biblioteca Nacional de Chile. When these resources were outstripped, the interlibrary loan staff at the library of the National Gallery, specifically Gillian Grossman and Faye Karas, kept the books coming. At Middlebury, Rachel Manning has helped with all manner of interlibrary loan requests and library heroics.

Many people took the time to reply to queries large and small during my research, and for advice, expertise, documents and historical reminiscences, I thank Alexander Alberro, Eugenio Dittborn, Ángeles Donoso Macaya, Jason Dubs, Harris Feinsod, Mario Fonseca, Anthony Gardner, Michele Greet, Ara Merjian, Hernán Parada, Niki Raveau, Florencia San Martín, Marian Schlotterbeck, Adriana Valdés, Cecilia Vicuña and Raúl Zurita.

Over the broad arc of this project, James Nisbet and Stephen Whiteman shared critical feedback of the sort I've relied on for as long as I've been writing, just as Edward Sullivan generously made time for a *tocayo* without really knowing me at all. For her help on everything ranging from idiomatic expressions and hunting down books, to making phone calls on my behalf, I can't thank Mariana Tocornal enough — she's been my fixer on the ground from the start, and even before.

This book began, in a way, with a curiosity surrounding my own tangential relationship to *Studies on Happiness* from childhood years spent in Santiago. I thank my parents, Ed Vazquez and Debra Bodine-Vazquez, for sharing the idiosyncrasies of a life lived across the globe and for helping me understand the texture of our time in Chile. I've made my own home and life with Sepi Alavi, and I thank her for all that she is and all that we have together. She's super, still.

As I began this project, our son was about as old as I was when I lived in Santiago, and all throughout my writing he has been at my side, on my lap or within earshot. I learn more from him than I do from anything or anyone else. This is for him, for Felix.

What life and society require of each of us is a constantly alert attention that discerns the outlines of the present situation, together with a certain elasticity of mind and body to enable us to adapt ourselves in consequence.
– Henri Bergson[1]

The novel belongs to our parents, I thought then, I think now. That's what we grew up believing, that the novel belonged to our parents. We cursed them and also took refuge in their shadows, relieved. While the adults killed or were killed, we drew pictures in the corner. While the country was falling to pieces, we were learning to talk, to walk, to fold napkins in the shape of boats, of airplanes. While the novel was happening, we played hide-and-seek, we played at disappearing.
– Alejandro Zambra[2]

Shortly after my family moved to Santiago, Chile, in February 1981, we lost our family dog. A rescue from the pound, Issa was a medium-sized mutt with a full, black coat that made her appear bigger than her thirty-odd pounds, though she always seemed huge to me. We were living in temporary housing; a gate didn't latch, maybe a door was left ajar. Whatever happened, she disappeared. None of us — my family or the dog — were especially used to our surroundings, and when Issa hadn't come home by that afternoon, my parents feared we would never see her again. Roughly a third of the population of Chile lives in greater Santiago. In 1981, that would have been slightly under four million people, making it one of the larger cities in Latin America. Likely compelled by a shifting emotional cocktail of hope, despair and grief, my mother and I walked Santiago's unfamiliar streets for weeks — me in a stroller shouting Issa's name until my voice gave out.

Nearly two months later, we were in a large, government-issued car, maybe a Chevy Suburban, running errands with a few other families from the Embassy. From the high vantage point, my mother saw a mangy dog at a busy traffic circle in central Santiago, legs splayed just so as she lay in the shadow of a newspaper kiosk. My mother thought it must be Issa. Over the

protests of our companions, she jumped out of the car in the middle of traffic and ran. The stray didn't see her approach, but upon hearing her voice calling out 'Issa!', she jumped into my mother's arms. Issa was gaunt from her time on the street, with a fresh scar on her nose, and she showered my mother with kisses. I imagine my mother overwhelmed with emotion, holding this filthy dog and walking back to the car, ready to go home.

I don't actually remember any of this. I was small, and while my first memories do come from Santiago, they aren't these. My most vivid memory of Issa is of my mother speaking to my grandfather on an airport payphone one Florida morning in 1986. We were on our way to another home in yet another country — Saudi Arabia this time — when my mother found out my grandparents had put Issa to sleep. I can still see her tears. But as far as the episode in Santiago goes, I know the contours of the story well. Or at least as well as I can — its visual textures filled out by old photo albums, which, in my family, are grouped by year and country. But that's about it.

In Nona Fernández's novel *Space Invaders* (2013), the narrator struggles with childhood memories of Chile far darker than my own. As she puts it:

> *We don't know whether this is a dream or a memory. Sometimes we think it's a memory creeping into our dreams, a scene that escaped from one person's head, lurking in everyone's dirty sheets. It might have been lived once, by us or by someone else. It might have been staged or even made-up, but the more we think about it the more we're sure it's just a dream that gradually became memory. If dreams and memories were truly different, we might be able to identify its source, but on our memoryless mattresses everything is mixed-up and the truth is that it doesn't really matter anymore.*[3]

Stationed in Santiago as US diplomats, my family was both in Chile and outside of it; we lived in an alternate world with a different set of rules, governed by diplomatic immunity rather than the fear of being subject to a police state. We did not — I did not — live through the dream that Fernández's childhood protagonists did — far from it. But her point about early memories, I think, still holds. In relation to my own experience,

I'd call this murkiness a second-order memory, remembered and mine, even if shared at the kitchen table instead of warped by the displacements of a dream. Since it is hybrid already, and in this way truly my own, I like to imagine an additional layer, one routed through art and its creative licenses. I imagine how, on our walks to find Issa, we unknowingly passed small signs — over a trash can, maybe under a public clock — that asked *¿Es usted feliz?* 'Are you happy?' Probably it didn't even register. I certainly wouldn't have been able to understand it, let alone read it. But thinking that my mother and I shared space with it gives me pleasure. I imagine that perhaps the shelter our dog found, provided by a kind, or maybe distracted, newspaper seller, held the same question. Maybe it was everywhere, as if the question were haunting us, following us, just waiting to be noticed while we frantically looked elsewhere. We likely found Issa on an April day, and this questioning, such as it was, was not actually shown until November 1981. Never mind that the question did not find form in the city but was the product of photomontage. Maybe that's better. It feels more like my mixed-up memory that way.

The question *¿Es usted feliz?* — whether we saw it or not — was posed as part of the larger project *Estudios sobre la Felicidad* (*Studies on Happiness*), undertaken by the young Chilean artist Alfredo Jaar between 1979 and 1981. Certainly, it would have meant something to us at that moment of familial crisis, even though we, untouched by the repression and violence that had characterised the sociopolitical realities of Chilean society since the coup d'état on 11 September 1973, were not its target audience. Jaar has described the project as an 'escape valve'[4] — a way to respond to the acutely difficult time that was life under the dictatorship of Augusto Pinochet. As Jaar recalled in a conversation in 2005:

> *I remember that censorship was at its height, and worse than that, self-censorship, because people were scared. I wanted to play with that: what could be said, how far you could take it, and what the most poetical way of doing it was. Something almost watertight. I was reading [Henri] Bergson at the time, his studies on laughter, which I liked a lot, and that's what led me to 'studies on happiness'. I thought:*

> *'It's watertight, it's poetic, it's naïve; they're not going to do anything*
> *to me.' So then I decided on a program of seven interventions and got*
> *to work.*[5]

He added, almost an afterthought: 'I was very isolated in the art world.'[6] Over the course of the project, Jaar's isolation would partly wane as he received some critical support as well as the approval of a few important artists. Yet, on the whole, the strategic loquaciousness central to Jaar's early work was met with a silence that has continued to this day. As such, *Studies on Happiness* occupies a paradoxical position: it is a fundamental work in Jaar's own practice, a place where he developed various methods that continue to guide his artistic approach; but it is often discussed as little more than a preamble to a range of more complex analyses of projects he pursued after relocating to New York in 1982. Further complicating this reception, though Jaar's practice began in Chile, his early work rarely enters local histories of Chilean art, even as his critical reception has grown considerably in Chile since 1980. Thus, *Studies on Happiness* is doubly minor: it is often implicitly relegated to juvenilia or subject to the distortions of selective diminution in monographic contexts, *and* it is passed over in more contextually driven analyses rooted in the Santiago art world into which Jaar had at one point hoped to fully participate.[7] The following history situates Jaar's work among various debates and practices in and around Santiago circa 1980, and dwells in the powerful marginality of *Studies on Happiness* as a project. Jaar found a way, via a conceptually grounded and contextually rooted discursive openness, to frame a core question not only for Chile under Pinochet, but for Chile now as much as anywhere else. My interest in *Studies on Happiness* is not meant to fetishise firsts or origins, but to take seriously the work's minor status and to refract *through* it the city and scene that Jaar left, which mostly passed over his work in silence. I do not wish to insert Jaar into histories that he was left out of, but to fashion something of a micro-history, bounded by the work itself. The Chilean poet and critic Enrique Lihn puts it well:

Our story is written in things,
in certain people who try to explain it to themselves
out of respect for absurdity,
in the most remote corners of this city and, one step further
in the neighboring one.[8]

Studies on Happiness attempted to counter the isolation and fear Jaar felt
and saw in deceptively simple ways. Over two years, he variously posed the
questions 'Are you happy?' and 'What does happiness mean to you?'
to people in Santiago and recorded their responses. The multi-phase project
gathered a portrait of the capital city, putting faces to a population that,
shortly after the conclusion of Jaar's work, would be described as suffering
from a collective depression.[9] In creating a space to broach — however
obliquely — the fatigue of political violence, censorship and economic
instability, *Studies on Happiness* is an early instance of Jaar's 'aesthetics
of witnessing'.[10] A description often applied to later works in which he has
considered and documented local conditions of human suffering, this
'aesthetics of witnessing' is perhaps best exemplified by the photographic
installations that resulted from his 1985 trip to the now-abandoned Serra
Pelada gold mine in north-eastern Brazil, collectively known as *Gold in the
Morning* (1985–87, fig.29), or, most famously, in relation to the large and
diverse body of work grouped under the title *The Rwanda Project* (1994–2000,
fig.30, 31, 32), made in response and witness to the 1994 Rwandan Genocide.
As Jaar described in a 2005 conversation with Patricia Phillips:

> *When I began reading about the gold mine at Serra Pelada in Brazil,
> there were no images. No photographer had ever been there. I just read
> about this vast crater in the rain forest surrounded by one hundred
> thousand miners. Roughly at this same time, I received a Guggenheim
> Fellowship, and this allowed me to travel to Serra Pelada. This
> was the first time I decided to go see a place I had read about in the
> newspapers. Once I got there, I realized there was nothing equal
> to the experience of witnessing something rather than reading about it.
> From this moment on, I decided to be a witness as often as I could.*[11]

Rather than prompted by travel, in *Studies on Happiness* Jaar took stock
of the world around him. Fresh out of architecture school, he was looking for
entry into the small but lively local art scene dominated by a few groups
of artists — and their respective critical champions — who worked mostly with
performance, video and photographic imagery. Jaar developed a strategy

of direct and open questioning through a distinctive use of similar media, and his querying would take on additional importance with regard to its specific sociopolitical context. Pinochet's rule was in a period of transition, bracketed by the formal dissolution and renaming of the regime's brutal secret police in August 1977 — the Dirección de Inteligencia Nacional (DINA) became the Central Nacional de Informaciones (CNI) — and the nationwide protest against the junta that began in May 1983. As the rebranding of the secret police might suggest, the government was attempting to soften the ruthlessness of its early years and seeking a model of future-oriented governance. On 11 September 1980 — the seventh anniversary of the coup that toppled Salvador Allende's democratically elected government — two-thirds of the Chilean population, according to the official tally, approved a new constitution that paved the way for dramatic privatisation and other neoliberal reforms. This arguably fraudulently imposed constitution — one of the regime's most concrete pivots toward the future — has since governed Chile, although it was drastically rewritten in 2019 by a national constitutional convention in the aftermath of nationwide protests — known as the Estallido Social. The newly written constitution was overwhelmingly rejected by nearly two-thirds of the population in a national referendum held on 4 September 2022, and the work of developing a new document that addresses the concerns of all Chileans continues. All of which is to say: Jaar's asking took place at a time when there was much to discuss in Chile, even if it was risky to do so with candour.

Studies on Happiness is composed of seven phases.[12] Though the particular tactics of the wider scenario set in place by the project cohere into a structured whole, each phase differs in its mode of questioning and ultimate physical form; the individual elements overlap and rephrase, but never simply repeat.[13] These interwoven interventions, each with the goal of asking people to reflect on their own happiness, manifested as street actions photographed as they took place in the city or as entries in juried group exhibitions at a range of venues around Santiago. After a lengthy period of research and planning that comprised a proto-facet of the project, the public portions of *Studies on Happiness* started to take form in June 1980 with phase one: *Serie de Encuestas* (*Survey*, fig.1–3). Outfitted with

an interactive interrogative poster, Jaar stood on street corners in downtown Santiago as well as in the well-heeled neighbourhood of Providencia on various days over the Chilean winter, soliciting responses to specific questions 'in the manner of a sociologist'.[14] Over four distinct occasions, accompanied by a friend who kept watch for the authorities and another who took photos, Jaar held or stood by a large sign with the following two prompts: 'Estimate a percentage of happy people in the world' (fig.4) and 'Estimate a percentage of happy people in Chile' (fig.5). These appeared to the right of the project's title, *Estudios sobre la Felicidad*.[15]

In photographs that document one instance of the action, we see the artist adjacent to his poster, which has been placed in a doorway. Along with deploying crisp visuals — and even a stylised rainbow to cue happiness itself — Jaar placed small, open Plexiglas boxes beneath each question, housing them within the larger construction. Passers-by could opt for a percentage estimate of happy people in both the world and Chile. Split into intervals of 20 per cent each, pedestrians voted with mints provided by the artist, placing them in the appropriate clear box, or abstained by eating the mints. The general question of global happiness was a form of 'protection' for the more local, and loaded, question of happiness among Chileans.[16] Documentary images of Jaar's poster indicate that Chileans were perceived to fare slightly better than the global population in terms of happiness estimates, with at least some participants suggesting that 60 to 80 per cent of Chileans could be described as happy. Overall, however, the results overwhelmingly favoured the bottom percentiles, with a sizable majority for both Chile and the world in the 0 to 20 per cent range.

In August and September, Jaar followed these general queries with the more pointed and personal question 'Are you happy?'[17] Willing participants were again asked to either vote with white candies or abstain by eating them. Alongside a set of photographs and residual objects, the final presentation of this survey's results shows fixed percentages labelling the 'SI' and 'NO' boxes (fig.6). With 34 per cent happy and 66 per cent not — a nearly exact inversion of the official tally in approval of the 1980 constitution[18] — the outcome suggests that it was edited slightly to reflect a particular final response when shown following the poll itself.[19] The display took place

in September 1980 as part of the Salón Nacional de Gráfica de la Universidad Católica de Chile (National Salon of Graphic Arts of the Catholic University of Chile) at the Museo Nacional de Bellas Artes. As a whole, actions undertaken by Jaar on eight days over a period of three months, the supporting materials for those actions, as well as images related to the performances, comprise the *Survey* portion of *Studies on Happiness*, with the separate museum display of *Paneles de Votación* (*Survey Panels*) constituting phase two of the larger project.[20]

That Jaar stood on the street hoping and trying to engage strangers in conversation — whether for fifteen minutes or multiple hours at a stretch — signified an attempt to bridge the chill of distance that defined public space in Chile at the time. Gabriel García Márquez, in his narration of Chilean film-maker Miguel Littín's secret return to Santiago in 1985, after a twelve-year absence — written from Littín's perpective — described an urban centre full of activity but devoid of any contact. In motion on the sidewalk, Littín trained his eye on other people: 'They were walking unusually fast, perhaps because curfew was so close. No one spoke, no one looked in any specific direction, no one gesticulated or smiled, no one made the slightest gesture that gave a clue to his state of mind. Wrapped in dark overcoats, each of them seemed to be alone in a strange city. Faces were blank, revealing nothing, not even fear.'[21] On the newly built pedestrian promenade of the Paseo Ahumada, a few murmurs punctuated the guarded silence: '[O]nly on the street corners were there people talking, in low tones inaudible to the prying ears of the dictatorship. There were peddlers and a large number of children begging. But what most caught my attention were the evangelical preachers trying to sell the formula for eternal happiness.'[22] Jaar wanted to broach a similar topic, to draw out of the whispers that Littín had heard. Yet his mode was free of proselytising and instead deployed a series of questions.

Phase three of Jaar's project, *Retratos de Felices e Infelices* (*Portraits of Happy and Unhappy People*), with interviews undertaken in September and the resulting portraits exhibited in October 1980, followed a similar pattern in that Jaar engaged in a series of conversations with individuals and later exhibited documentary materials related to the exchanges.[23] These, however, were much more intimate discussions — one-on-one interviews — and

the resulting documentation presents specific responses coupled with personal information as well as passport-style photography of each participant. From 'dozens of interviews of various hours in length',[24] all filmed by the artist, Jaar created a series of official-seeming portraits containing a large frontal photograph placed above typed responses to a set of questions. He presented this mix of photographic and linguistic documentation in a quasi-diptych format, to the left of a shallow Plexiglas box that housed further information, the exterior of which was marked with a number meant to suggest the specific interview in Jaar's archive (fig.7, 9). Set atop a gridded background, Jaar pinned a notepad-sized piece of paper with handwritten personal details, including first name and last name initial; generalised address, age, marital status and occupation; general observations, presumably noted by the artist during each conversation; and the duration of the interview. Additionally, at the top of the page, Jaar affixed a small portrait of the interviewee with a stamp marking them as either 'happy' or 'unhappy'. Underneath this small sheet, he included two photographs of each participant both smiling and frowning (fig.8), and beneath these, contact prints of numerous small photos of the interviewee presumably taken during the interview (fig.10). These *Portraits of Happy and Unhappy People* were also exhibited at the Museo Nacional de Bellas Artes, as part of the Sexto Concurso Colocadora Nacional de Valores (Sixth Salon sponsored by the Colocadora Nacional de Valores, a Chilean bank) in October 1980.

As the above description suggests, Jaar's objects play with the visual tropes of individualised bureaucratic identification and the generalising impulse of a sort of 'pictorial statistics' — from the typed notes and purpose-made stationary (the upper-left corner of the notepad page bears the inscription 'Estudios sobre la Felicidad, Serie de retratos, A. Jaar') to the stamps conferring authenticity and the frontal, flat photographs of the interviewees, who sometimes stand against a slatted wall that evokes the height measurements of a mugshot.[25] As only certain bits of information were extracted from and set against the fluidity of both conversation and feeling, we cannot know for certain what any interviewee said while their photograph was taken, nor can the roundness of a long conversation be fully and adequately summarised with a few brief notes. We end up with individual

portraits in the form of dossiers and files that class each individual according to a binary distinction and provide supporting documentation. When asked, at the time, why he had chosen to deploy the visual language of identity cards and police files — an especially charged form of the 'aesthetics of administration' in the context of a police state — Jaar let the wider implications of this charged mode of visuality go unstated. Instead, he blankly asserted: '[T]hese are files, as impersonal as a file. These records are recorded on video, photographed and typewritten.'[26] Extant documentation shows that Jaar asked each interviewee a set group of questions during the wider conversation and the transcribed answers suggest a psychological portrait of each sitter. The questions were as follows:

1. *¿Es Ud. Feliz? [Are you happy?]*
2. *¿Qué significa para Ud. 'ser feliz'? [What does it mean to you to 'be happy'?]*
3. *¿Cuál ha sido el peor momento de su vida? [What has been the worst moment of your life?]*
4. *¿Cuál ha sido el momento más feliz de su vida? [What has been the happiest moment of your life?]*
5. *¿Cómo ve Ud. Su futuro, feliz o infeliz? [How do you see your future, happy or unhappy?]*
6. *¿Es fácil ser feliz? ¿Depende solamente en Ud.? ¿De que depende? [Is it easy to be happy? Does it just depend on you? What does it depend on?]*
7. *¿Es la Felicidad el ideal de la vida? [Is happiness life's ideal?]*

The available records of these interviews are limited to a photograph of the installation in the Museo Nacional de Bellas Artes (fig.11), where three portraits appear spotlit against a dark wall, as well as precise photographs of the documentary vitrines of two individuals: a 'happy' 37-year-old man, Agustin P.D. (case number 31); an 'unhappy' 24-year-old woman, Mirna K.G. (case number 58); and a third, unnamed man (case number 27). Agustin was a carpenter Jaar knew; Mirna was a classmate of Jaar's brother, who was in medical school at the time; and the unnamed man, whose portrait

was photographed at a distance, rendering his 'happiness' or 'unhappiness' unknown, was a friend of Jaar's from architecture school.[27] In fact, Jaar completed only these three *Portraits*, assigning them arbitrary 'case numbers' to suggest that they were chosen from a much larger array of finished objects.

For phase four, *Situaciones de Confrontación (Presentaciones Públicas de Felices e Infelices)* (*Situations of Confrontation (Public Presentation of Happy and Unhappy People)*, fig.12–15), which also took place in October 1980, Jaar staged a more fluid conversational experience as part of a group presentation, the Segundo Encuentro de Arte Joven (Second New Artists Exhibition) at the Instituto Cultural de Las Condes, a smaller art space in the affluent neighbourhood of Las Condes, in the north-eastern part of Santiago. The set-up was direct: Jaar advertised that at a certain date and time two people who had participated in the interviews that comprised *Portraits of Happy and Unhappy People* — one 'happy' and the other 'unhappy' — would be present in the space and that the full video recordings of their interviews would be played with the interviewees present. The individuals sat atop white stools against dark backgrounds, with a television set placed between them, on which the interviews played as the audience sat mostly cross-legged on the floor. During the run of the Segundo Encuentro, Jaar had initially planned three discrete *Situations of Confrontation*, but ultimately staged only two conversations — one with two men and another with a man and a woman, all of whom are pictured in the extant documentation of the events. Only one individual who was a *Portrait* subject appeared — the young medical student, Mirna — suggesting that Jaar, while unable to reach his goal of one hundred portraits, did, at a minimum, have a larger group of completed interviews than the three he worked into full *Portraits of Happy and Unhappy People*.[28]

The novelty of this presentation — as Jaar would explain, 'I don't *represent* anything; I don't work with traditional systems of *representation*: here I am *presenting*'[29] — found form in the potentially transformative reality of actual conversation it triggered. In Jaar's description:

> *People started to gather and to listen to the pre-recorded interview,*
> *and afterwards, suddenly, came the question. A member of the audience*

fig.1

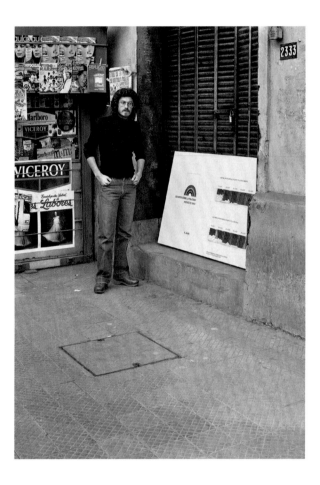

Alfredo Jaar, *Survey (Studies on Happiness, 1979–81)*,
1980, photograph

fig.2

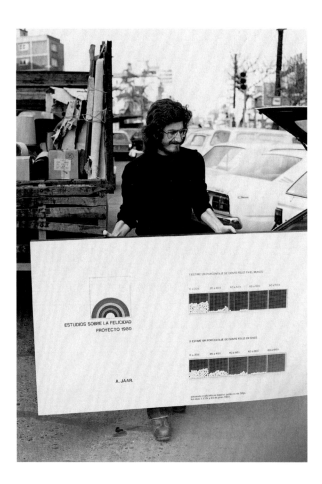

Alfredo Jaar, *Survey (Studies on Happiness, 1979–81)*,
1980, photograph

fig.3

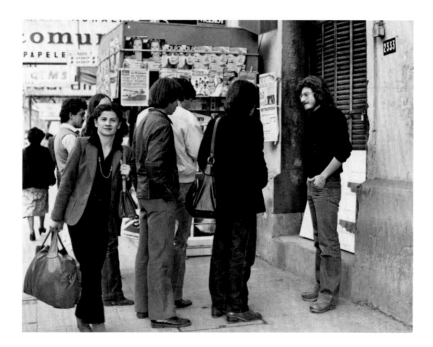

Alfredo Jaar, *Survey (Studies on Happiness, 1979–81)*,
1980, photograph

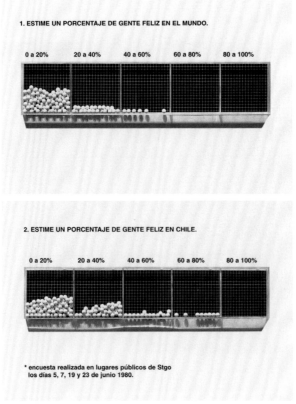

Alfredo Jaar, *Survey Panels (Studies on Happiness, 1979–81)*,
1980, photograph

fig.6

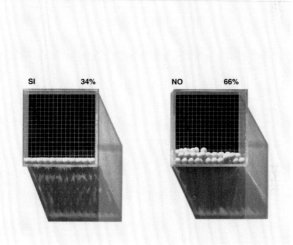

Alfredo Jaar, *Survey Panels (Studies on Happiness, 1979–81)*,
1980, photograph

fig.7

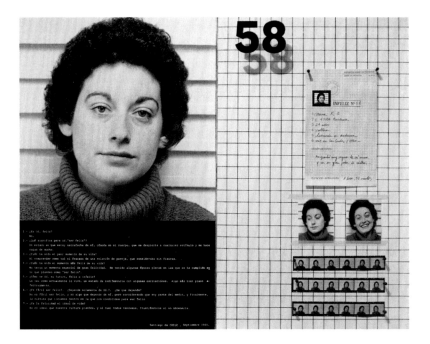

Alfredo Jaar, *Portraits of Happy and Unhappy People (Studies on Happiness, 1979–81)*, 1980, photograph

fig.8

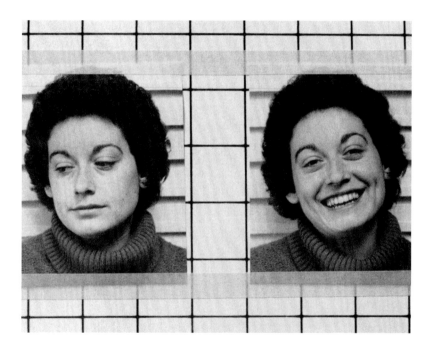

Alfredo Jaar, *Portraits of Happy and Unhappy People (Studies on Happiness, 1979–81)*,
1980, photograph, detail

fig.9

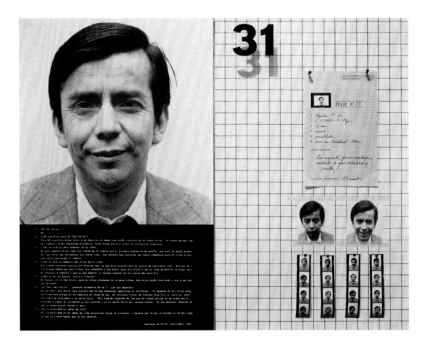

Alfredo Jaar, *Portraits of Happy and Unhappy People (Studies on Happiness, 1979–81)*,
1980, photograph

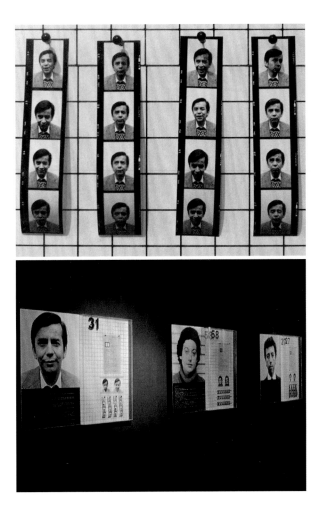

Above: Alfredo Jaar, *Portraits of Happy and Unhappy People (Studies on Happiness, 1979–81)*, 1980, photograph, detail; Below: Alfredo Jaar, *Portraits of Happy and Unhappy People (Studies on Happiness, 1979–81)*, 1980. Installation view, Museo Nacional de Bellas Artes, Santiago

fig.12, 13

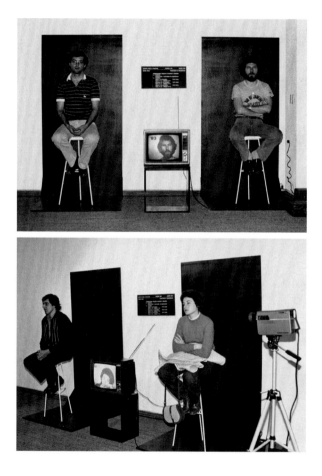

Alfredo Jaar, *Public Presentation of Happy and Unhappy People
(Studies on Happiness, 1979–81)*, 1980, photographs

fig.17

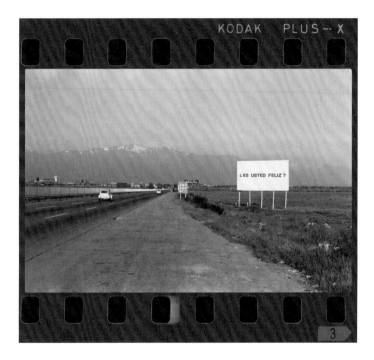

Alfredo Jaar, *Public Interventions (Studies on Happiness, 1979–1981)*,
1981, photograph

fig.18

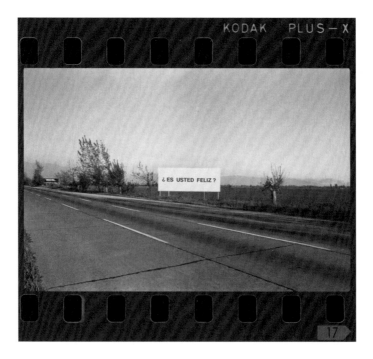

Alfredo Jaar, *Public Interventions (Studies on Happiness, 1979–1981)*,
1981, photograph

fig.19

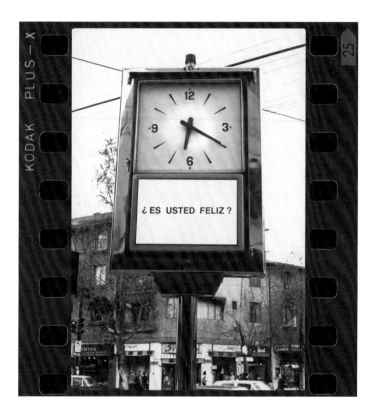

Alfredo Jaar, *Public Interventions (Studies on Happiness, 1979–1981)*,
1981, photograph

fig.20

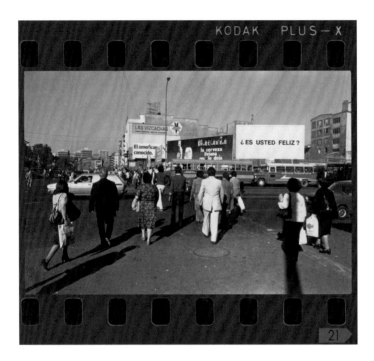

Alfredo Jaar, *Public Interventions (Studies on Happiness, 1979–1981)*,
1981, photograph

asked the individual whom I had labelled as 'unhappy' whether being labelled as 'unhappy' made him even more so. And that was the question that broke open the meeting. They stayed for two hours, these people, talking about happiness. In an art space.[30]

The setting in motion of a situation driven by dialogue and exchange changed everything. In the pages of the left-leaning weekly news magazine *Hoy*, Jaar remarked upon how, after this experience, 'the work began to control me. Each time it produced a real and proper therapy; there was real hunger to weigh in, and [the experience] produced that which I was seeking: a freedom in art and the possibility to create new situations and environments.'[31] Jaar has often used his training in architecture as a way of explaining the site-responsive and contextual nature of his art practice. Yet it is *here*, in these conversations, that he began to experience not only how his planned work might respond to the realities of the world, but also how, in real time, his art could create its own set of realities that might impact the wider contexts he was seeking to respond to in the first place.[32]

The final phases of *Studies on Happiness* — phase five, *Intervenciones Urbanas* (*Public Interventions*); phase six, *Obra Abierta y de Registro Continuo* (*An Open Work — A Non-Stop Record*); and phase seven, comprising *Video Documentation* from *An Open Work — A Non-Stop Record* — differ radically in the social spaces they respectively created, though they ultimately shared an exhibition venue as part of the Séptimo Concurso Colocadora Nacional de Valores (Seventh Salon sponsored by the Colocadora Nacional de Valores) at the Museo Nacional de Bellas Artes in November and December 1981.[33] Jaar's *Public Interventions* (fig.16–20) are the most well-known images related to *Studies on Happiness*. The photographs of large billboards flatly asking *¿Es usted feliz?* — in downtown Santiago, set against the mountains ringing the city, or elsewhere in the greater metropolitan area — are almost disruptively iconic, often standing in for the entire project and eclipsing the wider give-and-take that Jaar aspired to create. More to the point historically, these seductively blunt images have given rise to a misunderstanding — one courted by Jaar for a time at least — that these billboards were physically installed throughout Santiago's

environs. They were not. They were created and exist as a series of photomontages, a kind of urban proposal for work that could perhaps have existed under different circumstances. Their near reality as anonymous posters that I might have moved past with my mother in the confused space of my memories of our lost dog isn't too far off from the actuality of their (non-)presence in the city.

But they have often been described otherwise. Consider, for example, Luis Camnitzer's narrative of Jaar's project:

> *In 1980* [sic] *... Alfredo Jaar (1956–) filled Santiago de Chile with billboards asking 'Are you Happy?' Given the atmosphere of terror imposed by the dictatorship, the question was an extremely loaded one and was a good example of 'contextual art'. In the Museum of Fine Arts, viewers were stopped and invited to answer the same question for a poll, and this was recorded on videotape. They were given mints to be placed into clear plastic containers marked with the possible answers to the question. People also had the choice to abstain, in which case they were allowed to keep the mint and eat it.*[34]

Aside from the misdating of the *Public Interventions*, this summary reads like a dream-work condensation of the project, with elements of phases one and six blended together, even as many of the specific details are correct. However, it is hard to blame Camnitzer too much, for Jaar's own summary of his billboard project describes it as occurring in 'diverse public spaces in Santiago + photo documentation'.[35] At stake in this confusion is a fundamental mischaracterisation of the relative weight of repression on both artistic practice and direct speech more generally. While dissent found form in Chile in the early 1980s as anonymous graffiti — perhaps culminating in the 'No +' (pronounced *no mas,* or 'no more') slogan devised by the artist's collective Colectivo de Acciónes de Arte (better known as CADA) at the end of 1983 — formally renting advertising space would have been beyond the scope of tolerable critical language (though Jaar did go so far as to get pricing quotesfor the billboards[36]). What actually happened, to the best of my knowledge, is that Jaar produced a series of photomaquettes

that were shown at the same time as the phase six installation of *An Open Work — A Non-Stop Record* at the Museo Nacional de Bellas Artes.[37] The clearest description of these works comes from Chilean art historian and critic Ana María Risco:

> *[O]riginally maquettes or designs for the full intervention, these images 'realize' a documentary access to the fears, the out of phase utopias and the cultural transformations happening in the public spaces of the time.... [These images] have lost their status as projects and constitute a relevant part of an emblematic artwork of the period, which definitely took place.*[38]

Yet this is only part of the story. Santiago was, and remains, a large city, and Jaar's own language at the time, or perhaps the ambiguous information provided to journalists, did give these billboards something of a public life. One contemporaneous description offers that Jaar 'transferred the question "are you happy?" to street posters in central thoroughfares and under public clocks in Santiago.'[39] Another provides more precise narration, explaining that

> *the last step was photographic documentation of a street intervention in Santiago with the unsettling billboard 'are you happy?' that changed meaning depending on whether it stood near a clock, a lonely stretch of road, a kiosk, or a garbage can.... These photos accompanied his* Open Work *and reiterated the artist's intentions: his use of billboards, of photography, of television, carries with it a meditation on communication technologies, the new languages of art, and of the manipulative power of these means over people.*[40]

This phrasing makes it unclear whether the interventions actually took place, though the implication would seem to be that they did. Jaar's own recounting leaves even less room for ambiguity. The artist asserted his interest in the relatively aggressive gesture of the billboards, as he also considered the different valences that his question would hold when placed over a trash can or next to a newspaper kiosk, whether it be the hollowness of consumerism

or the routine failings of world leaders. As to what he purportedly did, Jaar has explained:

> *I made a series of urban interventions where the question 'Are you*
> *happy?' appears in distinct places: on the Alameda, as a central axis*
> *in the city at the crossing of North-South. Later, three moments for*
> *the pedestrian, which are those that structure the work in greater detail:*
> *a clock, with which I incorporated temporality: am I behind, am*
> *I ahead. The question arises: For what? I therefore joined this theme*
> *to happiness. The same thing happens with the trash can, where*
> *the conjunction was with getting rid of something, the act of throwing*
> *something away, of rejecting something that no longer has use,*
> *and raising the question of happiness. You see? But I raise the question,*
> *because in general I throw away something that makes me 'unhappy'*
> *but could make someone else 'happy'. Lastly, when one confronts*
> *the issue with the newspaper kiosk, with the news, with the 'panorama*
> *of what happens in Chile and the world', the issue becomes obvious.*[41]

Nowhere in the context of his remarks does Jaar describe these images as photomontages; instead, they are exclusively considered as urban interventions that took place in the city itself.

Attentive looking at the photographs themselves, however, betrays their status as maquettes. The billboard set against the mountains looks a little too white, just as the two photographs of billboards above busy streets show Jaar's question hovering at enough of a distance from their surroundings to raise suspicion. They wear the evidence of their manipulation rather plainly when seen in person, but I will admit that I had not questioned their presence in the city until Jaar explained their montage status to me. Yet not everyone has seen them in person, nor been guided to the details and idiosyncrasies of their facture by the artist. In fact, two of the three magazine articles quoted above include a few photographic reproductions of the images that comprise the *Public Interventions* at such a scale and resolution that they appear completely believable as real-life snapshots (fig.28). A contemporaneous reader could well be forgiven for seeing an intersection

they knew well and assuming they had missed the run of Jaar's billboard because their errands had taken them elsewhere that week. No matter that the content of Jaar's message would have read as too confrontational to have occupied a formally defined public space for any stretch of time.[42]

As far as the reproductions go, Jaar did not have a thought-out strategy of purposeful media disinformation, but he well understood the impact of the photographs themselves and the starkness of their message inserted into the everyday spaces of Santiago.[43] Had he been thinking of spoofing the media to make a point, however, he would have been in good company. Consider the example of *Happening para un jabalí difunto* (*Happening for a Dead Boar*, 1966, fig.39), a work created by the Argentinian artists and writers Roberto Jacoby, Eduardo Costa and Raúl Escari, who worked collectively as Arte de los Medios (Media Art) in producing an 'anti-Happening' published by the Buenos Aires daily *El Mundo* on 21 August 1966. The artists essentially fabricated an art event for explicit dissemination in the newspaper, using a series of staged photographs and a false press release that they provided to the media. As Jacoby, Costa and Escari described in their 'A Media Art (Manifesto)' of 1966:

> *This false report would include the names of the participants, an indication of the time and location in which it took place and a description of the spectacle that is supposed to have happened, with pictures taken of the supposed participants in other circumstances. In this way of transmitting the information, in this way of 'realizing' the nonexistent event, in the differences that would arise from the separate versions that each transmission would make from the same event, the sense of the art work would appear. The work would begin to exist in the same moment that the consciousness of the spectator constitutes it as having been accomplished.*[44]

For the Argentines, responding to a moment of increasing disinformation in the media following the June 1966 coup d'état in their country, the work, such as it was, would live in the minds of readers, who, upon seeing an article asserting its reality, would construct varied imaginings and beliefs of the

staged event. As reported, the work carried a valence of truth, even if it simply existed in the newspaper. As Jacoby would write elsewhere, considering the overall strategies of such work, it staged 'a play with the reality of things as they are and the unreality of information, with the reality of information and the unreality of things, with the materialization by means of information media of imaginary events, an imaginarium constructed over another imaginarium'.[45]

Though grounded in the specifics of the Argentine context, the basic assertion that falsehoods become facts because such facts dwell in an ecosystem of an unreal reality produced by media, which then shades the truth-value of both, is eerily prescient today. For Jacoby, the mythical aspect of the work — voiced through Roland Barthes's description of the power of 'an artificial myth' in *Mythologies* (1957) — was a by-product of the interface between the art world and the mass media.[46] In Jaar's case, given the widespread circulation of the photomaquettes, and indeed of their occasionally synecdochical relationship to *Studies on Happiness* as a whole, the myth — or at least purposeful ambiguity — has become something of a reality in the minds of many. That Chileans have approached Jaar to tell him that they saw his billboards on their streets and how deeply they mattered suggests the power and fallibility of memory — or the desire to claim a certain 'fellow traveller' status, regardless of the facts — just as much as it ascribes a certain life to the artwork itself.[47] Dreams and memories, here again.

The last element of the project, the video installation *An Open Work — A Non-Stop Record* (fig.21–23) that shared space with the photo maquettes in the Museo Nacional de Bellas Artes, made a much more explicit use of media.[48] Among a larger group installation, Jaar placed a chair atop a small platform set against a neutral-coloured backdrop spotlit by two lights. Before the chair stood a microphone with a sign containing the title of the work and various prompts. At the opposite end of the installation was a video camera, focussed on the chair, and between the camera and chair was a television screen attached to a VCR set on record; the television screen played a live feed of the footage. Museum-goers were invited to sit in the chair, beholding themselves in real time on the television; if they were so inclined, they might have also answered Jaar's questions, outlined as follows:

1. Basic Information
 a. Nationality
 b. ID Number
 c. Age
 d. Occupation

2. Questions
 a. Are you happy?
 b. What does happiness mean to you?

Time: Unlimited

Jaar would visit the installation at various times and take Polaroids of the TV screen to post on a bulletin board above the VCR. These photos (fig.24) as well as recordings of individual responses (fig.25) comprise the documentation of *An Open Work — A Non-Stop Record*, which Jaar now counts as phase seven of the overall project. Numbering among the more consequential events of his life and career, Jaar's installation was awarded a prize that allowed him to travel to New York in 1982. Though he travels widely, he has lived there ever since.

In the archival footage I have seen, people respond to Jaar's prompts with varying degrees of seriousness and sincerity. Aspiring actors treat the installation as a theatre set; a father makes faces for his young daughter; a few well-established Chilean artists offer statements before the camera, occasionally a poem or an allegorical tale; women adjust their make-up; a preppy young man jokes with friends standing off-camera. Many sit, read Jaar's prompts quietly to themselves, then take a moment — sometimes a good while — before either getting up in silence or offering a brief response. Some critics, approaching this array of responses, found that 'vanity, coquetries or the novelty of "seeing oneself on TV" overshadowed the question at hand';[49] whereas others read the behaviours a bit more critically: 'faced with a seemingly common question, spectators enacted every defence mechanism possible, responding with stereotypical phrases into a camera that corrals their identity and dares them to invent a new image "for the

TV"'.[50] Rather than indicating simple narcissism, the array of flirts and stock gambits can — and should — be understood as a type of subjective armour, a protective envelope insulating each participant from the camera's dispassionate recording and indeed the world around them.

The Chilean writer and critic Adriana Valdés, who first met Jaar after he approached her following a lecture she delivered around this time, and who then became his main supporter within the Santiago scene, noted this expressive tension and the gaps and beats it created in a short essay on *An Open Work — A Non-Stop Record*, likely written at the request of the artist and published by him as a sort of small catalogue to accompany the video installation (fig.26).[51] Valdés's text divides the polarities of the work between the force of the televisual medium and received notions of 'happiness' itself:

> *The framework/system* [Jaar's scenario] *is important in this work …
> because it conditions individual manifestation. And it does so by drawing
> on two clichés: TV and the question of 'happiness'. Both set in motion
> a series of stereotypical responses. The framework's function is to
> record those stereotypes and also the hesitations and withdrawals of
> each subject, by means of the tension provoked through video.* Studies
> on Happiness *become[s], then, a record of the narrow margins
> of freedom that stereotypes allow.*[52]

Triangulated between the video camera and TV screen — with the installation's straightforward mechanics and the public's participation in the creation of televisual images, both novel and personal — two 'phantoms' ensnare the viewer: their imagined identity and the related sense of societal expectation.[53] Jaar's work catches the cross-threading of these factors in real time.

Valdés's essay offers a transposition into the visual arts of her earlier analysis of Chilean literature, published in the more widely circulating Jesuit periodical *Mensaje*,[54] in which she addressed writing that knowingly 'incorporate[s] signals of its own silence'.[55] Such silence — as a glimmer of potential, as much as an index of fear — was of great interest to Jaar, even as he would consider it through the technological novelty and confrontation

of the televisual experience he created for participants. Separate from the time-capsule-like document of the video recording itself, Jaar's attention turned, as he put it, to 'the real, concrete, and open possibility that of the 6,000 visitors who I think visited the exhibition, that in a given moment, I offered them the chance to use a television; people suddenly found that they could use a television as a pretext and as a means for art and in the service of authentic individual manifestations.'[56] It could be argued that few met the camera prepared to open themselves up in such a forum, but many who sat on Jaar's stool arrived with an 'authenticity' that felt appropriate to the moment and venue. Yet to even frame the possibility of an unguarded response to the televisual image means having to confront the wider control exerted by the military junta over the media. As the narrator of Alejandro Zambra's *Formas de volver a casa* (*Ways of Going Home*, 2011) puts it, in his youth he understood Pinochet as little more than a TV host, putting a fine point on modes of disinformation and public address.

> *As for Pinochet, to me he was a television personality who hosted a show with no fixed schedule, and I hated him for that, for the stuffy national channels that interrupted their programming during the best parts. Later I hated him for being a son of a bitch, for being a murderer, but back then I hated him only for those inconvenient shows that Dad watched without saying a word, without acceding any movement other than a more forceful drag on the cigarette he always had glued to his lips.*[57]

That the media circuitry of *An Open Work — A Non-Stop Record* may have encouraged — in the privacy of one's own mind at least — the naming of a feeling, the voicing of something otherwise left unsaid, seemed enough to the young artist.

Jaar has cited canonical works of conceptualism like Hans Haacke's information-driven *News* (1969) and *MoMA Poll* (1970) as references for various facets of *Studies on Happiness*.[58] Yet the informational emphasis of such sociopolitical work — evident in Jaar's handling of data — can overshadow the conversational slant that *Studies on Happiness* sought

to enable, as perhaps best exemplified in the open exchange generated by the *Situations of Confrontation* that Jaar found so electrifying. While models for the spirited discussion he hoped the project might elicit can be found in Jean Rouch and Edgar Morin's classic of cinéma verité, *Chronique d'un été* (*Chronicle of a Summer*, 1961), which repeatedly asks 'Are you happy?' on Parisian streets in the summer of 1960, and in Pier Paolo Pasolini's *Comizi d'amore* (*Love Meetings*, 1965), these precedents were unknown to Jaar at the time.[59] In general, however, his questions and stagings — at least those that didn't involve *compañeros* knowingly invited to participate — were routinely met with sideways responses or tentative replies, if any at all.[60] And that was the point, too.

As such, while *Studies on Happiness* figures a form of conceptualist-inspired performativity held within its dryly informational presentation, the work equally engages with the stakes of portraiture and effacement in Chilean art circa 1980. Many among the small and fractious group of artists and writers in Santiago that came to be known as the *escena de avanzada* were drawn to problems of individual precarity and social cohesion as indicated in alternately blank or expressive modes of the human face.[61] At the same time, *Studies on Happiness* encouraged participants to talk, and in so doing deployed itself as a vehicle for a type of witness and testimony that was particularly important at that moment in Chile, when revelations around political violence and the shadows of the country's detained and disappeared made speaking out imperative. Over the two years of its seven phases, the iterative nature of Jaar's project and his various media strategies privileged a renewable openness, a clean slate that encouraged — or at least broached — some measure of honesty shared in public space and among strangers. To put it as plainly as possible, in *Studies on Happiness*, Jaar sought to particularise the default anonymity of the face with the honesty of the voice, inasmuch as his participants felt able to speak and comfortable in doing so. If the work ended up a picture of that furtive interrelationship, it is portraiture and voicing all the same.[62]

When and how we use our voices is something modelled and practised, and as particular to a household as to a culture, political environment or media ecology. Reminiscing on different valences of speech, the narrator in another piece of fiction by Alejandro Zambra, the short story 'Mis Documentos' ('My Documents', 2014), recalls: 'I figured out that keeping quiet was a very effective way to fit in. I figured out, or began to understand, that the news obscured reality, and that I was part of a conformist crowd neutralized by the television.'[63] While this would have had very specific meaning in Chile in the early 1980s, I think anyone who has grown up with television in their house can relate. In Chile, however, many could not stand silent, even as the climate of fear and self-censorship that Jaar was describing was very real. Indeed, the ID-style photography in *Portraits of Happy and Unhappy People*, and also the close framing of *An Open Work — A Non-Stop Record*, not only evokes the imagery of state surveillance and police files but also echoes the images and photographs that anguished parents and family members, as well as artists, were deploying as a fundamental act of protest, drawing attention to the brutality of the regime through the silenced faces of Chile's detained and disappeared.

Though the practice of permanently disappearing political prisoners had nearly come to an end by 1980 — having been replaced by twenty-day arrests and all-too-common torture after the leadership and governmental framing of the secret police changed in 1977 — many of the faces of the approximately 4,000 disappeared could still be seen in plain sight, both as an aspect of individualised protests and as part of the wide-ranging strategies of human rights organisations.[64] Formal responses to state violence began almost immediately after the coup — notably, the founding of the Cooperative Committee for Peace in Chile (COPACHI) by various religious denominations and organisations including the Archdiocese of Santiago in September 1973, followed by the Vicariate of Solidarity in January 1976, after Pinochet shuttered COPACHI the previous month.[65] Alongside achieving early successes in gaining legal standing for families of the detained and disappeared to argue *habeas corpus* claims in court, the Vicariate published and circulated the bimonthly magazine *Solidaridad* (technically a church bulletin), which was dedicated to social issues. Between November 1978 and May 1979, the archbishopric

of Santiago and the Vicariate jointly published the seven-volume series *¿Dónde están?* (Where are they?, fig.40), which reproduced dossiers prepared by the Vicariate's lawyers on 478 detained and disappeared persons.[66]

The Vicariate listened to people when no one else would and developed a framework, archive and legal strategy for tracking instances of state violence. The premise underlying the Vicariate's work was simple. According to the sociologist and historian Vikki Bell, those working with the Vicariate

> *sought to help and protect the victims of the military repression in Chile by insisting that their lives were valued, that their experiences were worthy of collection and response; in the absence of the state, but* like *an institution of the state, the Vicaría collected the details and accounts, premised on a commitment to these fellow citizens and their families. The workers did so not least by the simple acts of* registering *what they were being told about what was happening, producing data and reports that included both individual and aggregate information about the cases and circumstances reported to them.*[67]

The Vicariate worked with an oversized document known as *la sábana* (the sheet), into which they added data and hoped to make connections across different cases and stories.[68] Among the most important documents compiled by the Vicariate were photographs of the detained and disappeared, which, depending on the quality of the images provided by loved ones, often required a laborious process of retouching and even rephotographing. Historian of photography Ángeles Donoso Macaya, in her careful analysis of the photographic practices of the Vicariate, notes that 'after being cropped, mended, and rephotographed (and sometimes photocopied), the portraits were catalogued in the photographic archive and disseminated through print media. This process, expectedly, produced a sort of standardization.'[69] That is, such manipulations, via the common steps of the process, came to define the visual language of the detained and disappeared. Most images show single individuals in frontal or three-quarter views, occasionally obviously cropped from a group, in relatively high contrast, with most backgrounds masked out in white. Quickly legible, they provide as little additional

information as possible in order to allow for reproduction as well as enlargement with minimal distortion.

These images travelled far from the comforts of their frames or family photo albums: they were transposed onto leaflets and city walls, pinned to the chests of protestors, and reproduced in magazines and other print media.[70] The Vicariate's set of books, with pages upon pages of uneven grids showing the faces of the detained and disappeared, extended the protest strategy of affixing images of disappeared relatives to clothing and posters that asked *¿Dónde están?* These images were mobilised, for example, by those who mounted a multi-week hunger strike, from May to June of 1978, in the sanctuary of three Santiago churches, or the more aggressive street actions of the Agrupación de Familiares de Detenidos Desaparecidos (Association of Relatives of the Detained and Disappeared, AFDD), who staged protests in August 1978 at La Plaza de la Libertad, opposite La Moneda palace.[71] As anthropologist Michael Taussig has written about responses to analogous experiences of terror in Colombia, where the de facto silence of the state was also countered with naming and photographs,

> *it is this presence of the unsaid which makes the simplest of public-space talk arresting in this age of terror — the naming by the Mothers of the Disappeared in public spaces of the name of disappeared, together with their photographs, in collective acts acquiring the form of ritual in which what is important is not so much the facts, since they are in their way well known, but the shift in social location in which these facts are placed, filling the public void with private memory.*[72]

Or, as the narrator in Nona Fernández's novel *La dimensión desconocida* (*The Twilight Zone*, 2016) bluntly puts it, 'each of these photographs is a postcard sent from some other time. A cry for help begging to be heard.'[73]

In Chile, as elsewhere, a closely cropped image of a face was a response to a national crisis. To provide a photo to the archive, retouch it for legibility, reproduce it for mass dissemination, carry it aloft in public, hold it close to the body, wave it in the air, paste it to a wall — all of these actions and more posed questions not only about the specific person pictured, but also, by association,

a wider question — the plural of *¿Dónde están?* — concerning all the others who were absent. Visual artists brought a particular skill set to this work, and many participated in the activities of the Vicariate or in the protest actions of the AFDD. Among them, artists Luz Donoso and Hernán Parada were involved in the archival cataloguing and preparing of images for the Vicariate. With the occasional participation of artists Elías Adasme, Víctor Hugo Codocedo and Patricia Saavedra, they used the facilities of the Taller de Artes Visuales (TAV), an artist-run institution that Donoso co-founded in 1974, after the Universidad de Chile purged many of its left-leaning instructors.[74] In the course of further circulating the faces of the detained and disappeared, Donoso created the variable and extendable *Huincha sin fin* (*Endless Tape*, 1979, fig.42) from copies of ID photographs she handled as part of her work for the AFDD.[75] Creating an amendable form that could be easily transported and quickly unrolled, Donoso taped together the photocopied enlargements of faces along with protest fliers, magazine pages and other ephemera. Parada has recalled that in including all manner of documentary material, Donoso hoped 'to synthesize all that she saw and considered relevant, to show to others. This was combined with the desire to go further, to try and educate and change the observer of this expressive object.'[76]

Donoso and Parada collaborated with Adasme and Saavedra on various *Acciones de Apoyo* (*Support Actions*) intended to 'amplify and multiply'[77] the faces of the detained and disappeared. In *Acciones de Apoyo: Intervención de un sistema comercial* (*Support Action: Intervention into a Commercial System*, 1979, fig.43), as well as *Registro de videos, Catedral de Santiago* (*Video Record, Cathedral of Santiago*, 1981), the artists played video cassettes they had made of photographs of the detained and disappeared.[78] The video in the Cathedral ran on a stage alongside other performances as part of an annual event organised by the AFDD, whereas the earlier work had unfolded in a more clandestine fashion. *Support Action: Intervention into a Commercial System* made brief use of the television screens on display in an electronics store on the Paseo Ahumada, momentarily interrupting the shop window's typical material with an 'artistic video' that held the recorded image of a woman named Lila Valdenegro, who was detained and disappeared in the city of Valparaíso in 1976.[79] The action generated a bit

of confusion and some conversation, with people in the store asking whether Valdenegro was a 'delinquent'.[80] Though this work scrambled, however briefly, the signals of official television in ways resonant with Jaar's available circuit in an *Open Work — A Non-Stop Record*, the artists were adamant that their use of media was only instrumental. The general name *Support Actions* was first applied to these interventions in the publication *Ruptura*, edited by CADA (comprised of Fernando Balcells, Juan Castillo, Diamela Eltit, Lotty Rosenfeld and Raúl Zurita), which features a text in which Donoso, Parada and Saavedra explain that 'modes of communication in these actions are the necessary nexus to materialize an action. Although they are indispensable in order to make-register-show and/or disseminate some action or theoretical material, they are not in themselves an artwork (although their influence exists), but rather elements/tools at the artwork's service.'[81] Whereas Jaar would assert that, whether they opted to participate or not, the presence of the television could be catalytic for the viewer with regard to what they might say, do or even think, and as such integral to the work, in *Support Action: Intervention into a Commercial System*, the screen served as one amplification device among many that raised awareness and united elements of the population around a common cause.

Yet Jaar was not alone in asserting the power of an 'open work'.[82] Donoso, Parada and Saavedra's *Ruptura* statement notes a range of performative precedents, including the direct antecedent of the 'proposición obrabierta' (open work proposition or open-ended proposition), defined as 'the possibility of including all actions destined to solve the DEDE [detained disappeared] problem as part of itself ... and creating a continuous system with the capacity (theoretical and practical) to adopt — deal with — influence and change the trajectory of certain social events'.[83] Parada's earlier and ongoing work *Obrabierta A* (*Open Work A*, fig.44, 45) helps define the theoretical parameters of these wider actions. Parada dates the still-developing project as starting on 30 July 1974, the day his brother Alejandro was abducted from his home in Santiago in the early hours of the morning. A large part of the project, undertaken in 1984 and 1985, involves Parada being photographed while wearing a mask of Alejandro's face, in effect materialising his brother's absence as well as animating the photograph used

to assert it. An early iteration of this work was presented under the title *Documentografica* (*Graphic Documents*) in a group show at the Galeria Coordinatora Artística Latinoamericana (CAL) in October and November 1979.[84] (Jaar would have his first solo exhibition, 'Objectos', in the same space immediately after, in November and December of that year.) Framed explicitly as an 'obra abierta', Parada displayed a series of photographs of his brother, as well as personal items and a bookcase with objects and documents related to him, beneath a sign noting the in-progress nature of the work — indeed, its openness. Also in 1979, Parada documented a series of urban interventions for which he held up a large image of his brother at various important locations around Santiago.[85]

In certain ways, these projects cannot be compared. Parada's *Open Work A* develops from and through personal loss and is as much an artwork as a process of investigation, a catalyst for extended inquiry; ultimately, it is a site of mourning. It demands acknowledgement — and hopefully resolution — for not only Alejandro Parada but all the detained and disappeared, just as its structure allows for new actions to be included within the singularity of the work. Its openness is like grief — fluid, but always there — while its assertion of incompleteness powerfully suggests the excruciatingly unresolved reality of living with disappearance. Jaar's *An Open Work — A Non-Stop Record* incorporated openness in a more structural way, in that the artist defined a fixed set of parameters to create a framework for the indeterminate actions of participating individuals. Umberto Eco's theorisations of the open work — written in 1962 and rooted in avant-garde classical music while addressing a range of literary precedents — describe an authorial position generally aligned with the strategies of Parada, Donoso and Jaar:

> *The author offers the interpreter, the performer, the addressee a work to be completed. He does not know the exact fashion in which his work will be concluded, but he is aware that once completed the work in question will still be his own. It will not be a different work, and, at the end of the interpretative dialogue, a form which is his form will have been organized, even though it may have been assembled by an outside party in a particular way that he could not have foreseen.*[86]

fig.21

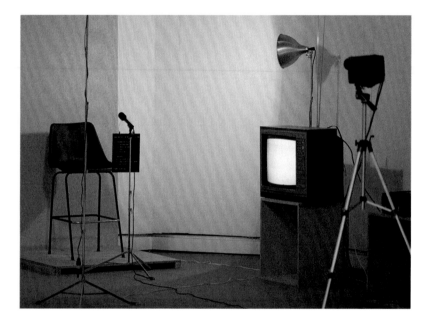

Alfredo Jaar, *An Open Work – A Non-Stop*
Record (Studies on Happiness, 1979–81), 1981, photograph

fig.22

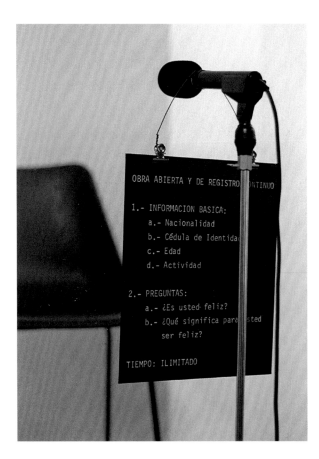

Alfredo Jaar, *An Open Work – A Non-Stop Record*
(Studies on Happiness, 1979–81), 1981, photograph, detail

fig.23

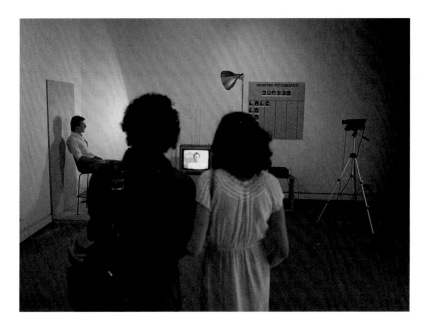

Alfredo Jaar, *An Open Work – A Non-Stop*
Record (Studies on Happiness, 1979–81), 1981, photograph

fig.24

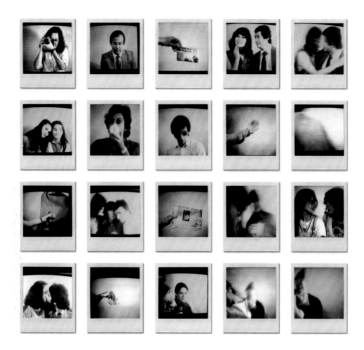

Alfredo Jaar, *Video Documentation:*
Polaroids (Studies on Happiness, 1979–81), 1981, polaroids

fig.25

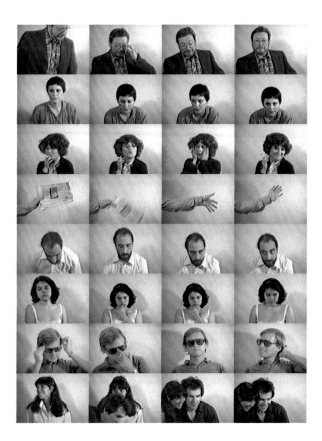

Alfredo Jaar, *Video Documentation (Studies on Happiness, 1979–81)*, 1981, video stills.
Diamela Eltit appears in the second row from the top; and Raúl Zurita in the fifth

fig.26

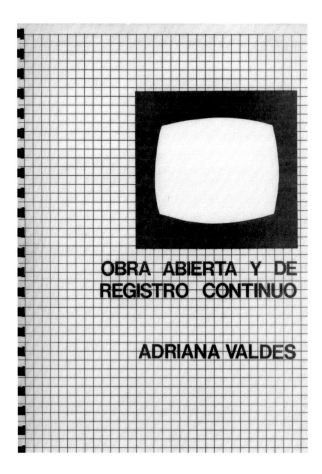

Cover of brochure for Alfredo Jaar, *An Open Work — A Non-Stop Record*,
1981, with essay by Adriana Valdés

fig.27

Alfredo Jaar's hand-written list of the recipients of his brochure for *An Open Work — A Non-Stop Record*, 1981

fig.28

ARTES VISUALES

Felicidad en la mira

Alfredo Jaar cierra un ciclo que invita a soñar, reflexionar, actuar

POR ANA MARIA FOXLEY

"¿Es usted feliz?"

"No sé, sólo sé que me siento bien", contesta una mujer madura. "Soy lo más feliz que hay", responde una lola en tono saltarín. Una joven se arregla el maquillaje y huye. Un hombre exclama. "Estoy a punto de ser feliz", luego desaparece. Jóvenes, viejos, niños, artistas, funcionarios del Museo de Bellas Artes circulaban observando las obras expuestas en el VII Concurso de la Colocadora Nacional de Valores. Algunos cuadros y esculturas les merecían un vistazo, otros un comentario. Pero de pronto, una cámara y una pantalla de televisión los imanaban hacia un rincón de la sala.

"Oye, me veo igual que en la tele", comentaba alguno con exclación, al mirar sucesivamente el lente que lo apuntaba y a la pantalla que lo reflejaba como en un espejo, junto a la instalación del piso, el micrófono y la tarjeta del interrogatorio "Nacionalidad, cédula de identidad, edad, actividad. ¿Es usted feliz? ¿Qué significa para usted ser feliz?"

Las preguntas no dejan escapatoria. La cámara es implacable. Registra cada gesto, cada balbuceo de temor, cada indicio de *voyerismo* de los espectadores que se atreven a sentarse en el banquillo y "jugar el juego" que propone el artista Alfredo Jaar. Ante una pregunta que puede parecer un lugar común, los espectadores ponen en funcionamiento todos los mecanismos de defensa a su alcance, respondiendo con frases estereotipadas a una cámara que acorrala su identidad y los desafía a inventarse una imagen nueva para "la tele"

Magia y realidad

Es su *Obra abierta y de registro continuo*, penúltima etapa de un trabajo de investigación y creación artística que ha recibido numerosos premios. Entre otros la beca internacional del último concurso de la Colocadora, que le permitirá permanecer por seis meses en Nueva York, ofrecándolo lo que se hace allá en artes visuales. Antes de partir, Jaar mostrará a algunos amigos y críticos el resultado final de su "obra abierta", con las reacciones del público y de otros artistas.

De sólo 25 años, Alfredo Jaar desde los 18 se definió por el arte... aunque estudió arquitectura con el afán de tener trabajo seguro. Allí aprendió "una metodología y una disciplina para enfrentar la realidad", reconoce hoy día, "un lugar donde cabe tanto la poesía como el frío razonamiento para crear imágenes y realizar obras"

En las que ha hecho hasta ahora hay mucho de todo eso, además de una inquietud antropológica y sociológica. También hay algo mágico, y no es raro. Su experiencia de niño lo determinó así.

Alfredo Jaar: incitando a una respuesta en el banquillo de "la tele"

Vivió diez años junto a sus padres, en La Martinica, de las Antillas francesas. Allí, entre negros y mestizos, quedó "fascinado por los rituales caribeños, la playa, la onda relajada y la magia". Tanto, que después de presenciar un festival internacional de magia, a los ocho años decidió ser prestidigitador "Así comenzó a aprender el arte de 'engañar' al público con malabarismos, y de paso, venci mi timidez asumiendo una postura de actor"

Después vino el regreso a Chile, la Alianza Francesa, una beca de tres meses a Francia y un tomar vuelo en lo artístico. dibujo, teatro, cine, todo, lo estudió con fruición "Lo que hago ahora es una síntesis de lo que fui captando anteriormente", explica Jaar. Todos los estímulos para él son válidos, el revisar la obra del norteamericano Kozuth, o las de Vostell y Beuys; el asistir a cuanta obra de teatro, ballet, cine o exposición se le pone por delante o el leer literatura hispanoamericana y discutir con otros artistas en encuentros y seminarios.

Hambre por opinar

En su primera exposición en 1979, en Galería CAL, comenzó con una serie de objetos realizados en un marco conceptual. Indagando sobre el arte nacional preguntó en el concurso de la Colocadora de ese año: ¿Qué pasa con la plástica chilena? Un texto y unas fotos de bocas modulaban las sílabas de la pregunta. Unos labios cerrados concluían con la respuesta tácita: "en la plástica chilena no pasa nada". Recibió una mención.

"Ahí la gente comenzó a decir que yo tenía sentido del humor", cuenta Jaar, "por eso me decidí a investigar sobre la risa. Descubrí que era algo extremadamente serio". De su pequeño homenaje a Hera... →

En la ciudad: preguntas inquietantes

HOY, 6 DE ENERO AL 12 DE ENERO DE 198...

Such an expansion, with a series of author/artist-defined indeterminacies and variable outcomes, could be deployed, as in the work of Jaar, Donoso and Parada, to ask questions about the state of society in ways alternately oblique and general-seeming, or directly in the service of a specific sociopolitical and humanitarian goal.[87]

This expanded category of artwork was recognised at the time in Santiago by critic Nelly Richard, whose influential, albeit contentious definition of an *escena de avanzada* had not yet been fully articulated and demarcated.[88] In April and June of 1979, Richard led a seminar on contemporary art at the Instituto Chileno-Norteamericano de Cultura in Santiago that most of the major artists in the city attended, including Jaar, who first met her in this context.[89] 'Seminar Arte Actual: Información, Cuestionamiento' (Seminar on Contemporary Art: Information and Critique) was a survey that considered land art, body art and critiques of painterly representation, and was predominantly Euro-North American in its references.[90] Following the seminar, which was meant to put Chilean art in a broader context, Richard wrote and self-published a typescript offering a summary view of contemporary art in Chile. Titled *Una mirada sobre el arte in Chile* and dated October 1981, it defines the contours of the 'escena "de avanzada"' — a term and categorisation that has since been applied to define much of Chilean production under the dictatorship, and that would ultimately exclude Jaar.

In mapping themes mostly clustered around photography and performance art, as well as strategies of generalised illegibility and erasure, Richard's text describes artists 'transforming mechanics of production and subverting the codes of cultural communication'.[91] Degraded, occasionally illegible photocopies of artworks support the analysis, elements of which appear hand-underlined for emphasis. In describing the disruptive effects of photography in Chilean contemporary art that began to take shape, per Richard's analysis, in 1977, and the medium's loss of autonomy in functioning mainly as documentation in relation to performative actions, Richard noted the shifting terrain of circulation and perception occasioned by artistic uses of reproductive media. She described practices, beginning in 1978,

which are rooted in an evolving dimension, based on a spacio-temporal

dynamic that modifies the fundamental materiality of the work during its development: Rosenfeld-Castillo annex the landscape as a part of the work, the Taller Bellavista [the original name of TAV] *proposes the reading of a public archive as an initial participatory exchange, Parada postulates the inconclusiveness — it does not end — of the biographical material (the disappearance of his brother) addressed in the work, etc.*

Though there are works of recording, intervention or participation (Adasme, Codocedo, [Carlos] Gallardo, Jaar, [Gonzalo] Mezza, Parada, Saavedra, etc.) that make use of diverse formal strategies (the body, landscape) and assert their technical recording in an intense gesture of semiotic opening, the works are relatively scant (slow, few), and their exhibitions relatively spread out (that is, their public itineraries tend to be quite segmented) for them to achieve more than a non-partial or fragmented viewership (sustained in a continuous way) that can participate properly in their fullness and can articulate their dynamic productivity.[92]

Richard stresses that the strategies under discussion make use of forms of photomechanical capture and media that move beyond the purely static and can therefore enact complex relationships between the staging and documentation of the fluid work described.[93] On these terms, an open work requires plural and flexible materiality — often beyond the borders of established aesthetic categories — to raise its questions and, ideally, foreground an engaged audience that can meaningfully participate. The expanded field that Richard sketches includes photodocumented performative actions; video-driven interactions between the artist and the viewer/participant in the context of an art space; and bounded, real-time performances and installations that make use of objects from everyday life. Such an enumeration dispenses with the nominally static media of painting or free-standing sculpture constructed of traditional materials, and instead favours a variable materiality that can sometimes be indeterminate relative to its execution while at others remaining complete and self-contained, just as the photographic records of such works gesture to actions or activities held fixed in their partiality at the level of the documentary image.

The radical incompleteness and formal openness exemplified by the works of Parada, Donoso and Jaar marked a limit case for understanding a group of actions or experiences as internally consistent individual works, especially relative to their overall duration and segmented display. As Richard pointed out, such strategies were not the default position among artists. Many others worked in more traditionally defined and circumscribed artist-driven performance or static media, even as they raised similar issues. Some were significantly more oblique in their references, often deploying their own bodies in performative situations, as in the work of Carlos Leppe or Diamela Eltit, or via appropriations of historical imagery in paintings, drawings and prints, as in the practice of Eugenio Dittborn.[94]

Leppe's performances, beginning in July 1974 with *Happening de las gallinas* (*Hens' Happening*), were quite influential in Santiago. Slightly older than Jaar, he often used clothing and make-up, and sometimes medical materials like plaster casts, to both define and constrain his body. In the four-channel video installation *Las cantatrices* (*The Female Singers*, 1979–80, fig.46), for example, Leppe's torso and arms are immobilised in a plaster cast, his face covered in stage make-up, and his mouth stretched and held open by a metal dental instrument — all while the artist pantomimes to the sounds of an unnamed operatic aria. Three monitors play back versions of Leppe's attempted lip-syncing, complemented by a fourth that displays and narrates a text written by the artist's mother, recounting Leppe's birth and early years, as threaded through the difficulties of her life at the time. The layering of references and imagery opens onto social roles and constraints, just as Leppe's immobilised body evokes torture and his mother's own strenuous labour.

Aspects of this work were produced by and with Richard as part of the installation *Sala de Espera* (*Waiting Room*) at Galería Sur in 1980.[95] In an influential analysis of Leppe's work, *Cuerpo Correccional* (*Correctional Body*), published on the occasion of the exhibition and created in dynamic relationship to the works installed, Richard focussed on Leppe's positioning of his own body as a variable sign caught in binding spaces of publicness, national belonging and cultural convention, in a 'corporeal dialectic'.[96] According to Richard's characterisation, the role of video and photographic capture in Leppe's work is one of urging viewers to square the artist's

corporeal presence with that which is typically seen on broadcast television and in more mainstream imagery. The body's role as a literal support for 'sacrifices to coercive cultural institutions'[97] is made visible, with make-up interpreted as an equally defensive and self-effacing mask worn by the artist, so as to install a bodily conformity, a stereotype.[98] Addressing the installation more generally, and the singularity of the biographical details on offer, Richard posits that Leppe's work forces a collision between his own life and image, and all that the viewer passively receives via television.

> *[T]he entrance to your* Waiting Room *via the (forced, inaugural) singularity of television or the operative mode of national information, instigates the viewer held in the gallery to compare your own body of harm with other bodies harmed daily on the ordinary format of the screen / to programme yourself as a telenovela or news flash in your daily work or domestic schedule / to polemicise the default meaning of your body debate / to frame your biography via a popularity unanimously televisual.*[99]

Even with the singular presence of Leppe's performing body occupying screens throughout *Waiting Room*, as part of an overall installation fragmented by lengths of fluorescent light, the format of the television compels a comparison with everyday life and its sites of terror, misinformation and pacifying programming. Through the metaphorical operation of his own performance at Galería Sur, Leppe used himself — and the modes of mediation enacted upon him — to raise the question of what bodies perhaps saw the show but were not captured on television.

Instead of opting, like Leppe, for performance to consider the violence wrought via forms of physical repression and the fluid steep of ideology, the painter Eugenio Dittborn turned to faces and bodies captured in found police and sports photography, which he manipulated and degraded via the blunt instrument of the photocopy machine, as seen in the work displayed at his slightly earlier exhibition 'Final de pista' ('Finish line'), held in December 1977, at Galería Época. Analogous to Leppe's fusion of operatic song and torture in *The Female Singers*, Dittborn's work exploited the

ambiguous relationship between physical effort and anguish in images of athletic exertion, just as he shaded the implied criminality of historical examples of mugshots with both the evidentiary pleas marshalled by photos of the detained and disappeared and the disciplinary gaze of surveillance. As explained in an aphoristic, manifesto-like text Dittborn wrote for the accompanying gallery publication: 'The painter owes his work to the photographic body, embalmed in and by the photocopy, a repository for photography's leftovers.'[100] That is, his practice of photomechanical distortion — enlargement, repetition, fragmentation — was grounded in the forgotten residues of lived experience, as captured on film and further ravaged by successive modes of reproduction. The variety of operations Dittborn associated with the interchange between photo and copy are legion:

> *He [the painter] owes his work to the intervention of the photocopy on the photograph, an intervention that automatically pales, calcifies, perforates, iodizes, drains, congests, weakens, dehydrates, revives, shrinks, suffocates, oxidizes, burns, salts, contaminates, moulds, tars, frays and erodes the surface of the photographic body. Preserving it destroyed.*[101]

For Dittborn, the operations required to get from a living moment, experienced between people, to its mass dissemination, in print media, materialise the profound frailty of the individuals reproduced, as the transformation of the living body into a photographic likeness consecrates a 'perpetual helplessness.'[102]

Dittborn's most important interpreter and occasional collaborator was the philosopher and poet Ronald Kay. (Richard has been supportive as well, though her criticism is more forcefully associated with Leppe.) Kay's short book *Del espacio de acá* (*On the Space Over Here*, 1980) offers, among other things, a careful analysis of Dittborn's work and the photographic image in the context of the Americas.[103] In marking out the operation held in Dittborn's figurative translations and distortions, Kay's book notes that photographic images

*continue indelibly, perpetuate themselves unforgettably in our precarious
eyes, transmitting with identical precision, their inexhaustible
information even long after those eyes, our ephemeral eyes, will have
disappeared. Memories that cannot come to an end. A rigorously
mechanized chronicle is registered in the actions fixed by a limitless
time; its actors are now the sudden stereotypes of an always
anachronistic now. A past that never existed is incessantly reborn
through the bodies incinerated by the light in the negative.*[104]

Kay's *Del espacio de acá* was published at the same time as Richard's
Cuerpo Correcional, and Kay and Richard shared a book launch at Roser
Bru's Galería Sur on 30 November 1980, in the same month as Jaar's
Situations of Confrontation.[105] The various pieces gathered in Kay's
collection meditate on, among other topics, photography's 'retrophysics'.
Naming an image's ability to draft the apparently concluded moment held
in the photograph into a future time of its viewing, retrophysics suggests
'an always-virtual interpolation of those other distant times in the apparently
closed and concluded continuum of the event'.[106] Seen in such a light,
the schematic presence of Dittborn's degraded imagery holds a density
of information in its fragments, with the textures of their unending, limitless
moments left to be populated by our own imaginings, as if postcards sent
from another time to be misread in the now.

Kay grounded his binding of the material actuality of the photograph
and its call to past and present virtualities — in its way, a trapdoor to
misrecognition and false projection — in a robust notion of witness, which
provocatively opens onto Jaar's own practice. Kay's narration of the
temporal complexity held in a photograph reads:

*Photographs possess a rare quality: beyond simply registering an
event by means of its optical footprint, every photograph stands as the
invisible material inscription of the potential look of a witness. (This
virtual role is first, and contingently, assumed by the photographer.)
This fated witness is not only a dynamic virtual presence within
the photograph, but also, and above all, within the event itself, since*

*the negative constitutes a translation (by means of contact) of the
event — its material continuation in other times, places and situations.*[107]

Set against Dittborn's self-consciously oxidised and contaminated handling
of the photographic form, this kind of testimony cannot but run aground
in the distortive husks of his imagery, as the textural form and presence have
been worn down to the hollowness of a mask. While the varied terrain
of stereotypical masking runs through *Studies on Happiness*, the issues
of witness theorised by Kay have been at the core of Jaar's practice since his
time in Brazil in the mid-1980s, when he was at work on *Gold in the Morning*,
if not earlier, and were most robustly developed in *The Rwanda Project*
in the 1990s. In the latter, Jaar's precise and varied engagement with several
thousand photographs he took in Rwanda in August 1994 addresses, in his
own words, 'the disjunction between experience and what can be recorded
photographically'.[108]

The Rwanda Project's response to the texture and horror of life and
death during the genocide underscores the limits of visual material to
adequately convey the tragedy Jaar witnessed. This is evident, for example,
in the textual withdrawal of *Real Pictures* (1995, fig.32), where Jaar placed
his photographs from Rwanda in individual archival boxes, each printed with
a precise description of the hidden object, and then simply stacked them
as minimal blocks, their imagery unavailable to the viewer. This strategic
removal explicitly grapples with the backdrop of international indifference,
in what art historian Griselda Pollock has described as 'the creation
and choreographing of the viewer's encounter with and reflection upon the
encounter with images in an image-saturated culture structured by its
unprocessed relation to Africa'.[109] Emblematic here is *Untitled (Newsweek)*
(1994, fig.30, 31), which displays the covers of *Newsweek* magazine published
from 11 April to 1 August 1994, the day the magazine first put Rwanda
on the cover, after one million people had been killed. This absence
of coverage — as covers were meanwhile published featuring, for example,
O.J. Simpson, Kurt Cobain and 'The Myth of Generation X' — is paired
with a short text by Jaar describing week-by-week political developments
and the rising Rwandan death toll. Faced with the horrors wrought by global

inaction, Jaar opted, generally, for aesthetic withdrawal and a measured presentation of information about Rwanda. In his engagement with his photographic archive in the face of such indifference, we can perhaps intuit the pain of Kay's retrophysics, whereby 'it is agonizing to break open this fossilized writing [of the photograph], to envision and mobilize its alphabet, which writes us by inescapably inscribing us in a collectivity that communicates through a presence opened up by the image.'[110]

Directly related to Dittborn's work in 'Final de pista', Kay composed a short text, 'Cuadros de Honor' ('Paintings of honour'), included in *Del espacio de acá*, that considers the disciplinary and flattening function of ID photographs, where individuality twists into standardisation.[111] 'Cuadros de Honor' offers that any reproduction of a standard ID image shades the photo with delinquency, noting that 'no one ever prints an ID photo in the newspaper when someone wins the 100-meter dash or gives money to [a charity like] Hogar de Cristo'.[112] The reproductions picture criminals or wanted individuals whose criminality is assumed, or — in a shift from the drift of Kay's remarks — those who have been disappeared. Dittborn's work, for Kay, operates in this space where order and state power hybridise with aspirations to individuality, just as that self-same individuality is subject to suppression via standardisation and its ultimate misreading by later viewers. 'Due to the regulatory and formalizing intervention of the mechanical eye,' according to Kay, 'the framing edge of the identity photo institutes a space of exchange, where the anxiety of the intimate and the dream of the singular trade through the stereotype.'[113]

The poet and critic Enrique Lihn — Kay's friend and collaborator — complemented this analysis with his own discussion of Dittborn's work.[114] In a text first published in 1979, he noted that in whatever time, 'the camera, which begins by documenting reality, becomes a *machine for stereotyping*'.[115] This process 'imparts a role to the subject at the cost of itself: distributing among individuals their "social masks"', and applying an identificatory violence to all it captures.[116] Lihn, for his part, stressed the flattening and erasure enacted by the camera's capture, whereas Kay asserted a dynamism held in the operation of the image, which constantly moves between blank generalisation and delicate particularity. As Dittborn described to Lihn

in a conversation held at Galería Época during the show's run, the photocopy helped him to see the mechanism of reduction and sameness applied to the 'burned, razed, devastated' subjects of photography.[117]

Dittborn distorted his source imagery through enlargement and reprinting in *Pietá* (1977), where the figure of a boxer, prone and dazed, his head resting on a barely visible rope, stands in for the lifeless body of Christ (fig.47). The specificity of Dittborn's subject bears mentioning: the image is of Bernardo 'Benny the Kid' Paret, a Cuban welterweight champion. Paret appears unconscious, having been knocked to the ground in the twelfth round by Emile Griffith on 24 March 1962 at Madison Square Garden in New York City, during an unsuccessful title defence. The unconscious Peret would never recover — he died from complications of brain haemorrhaging a little more than a week later.[118] The bout was broadcast live by the US television network ABC, on its *Fight of the Week* programme. In 1977, in a second-hand shop, Dittborn found a photograph of a TV screen showing the fight, taken by a United Press International (UPI) photographer and published in the Chilean sports magazine *Gol y Gol* in 1962.[119] Dittborn manipulated the reprinted photograph of a televisual image, dwelling on the ambiguous moment when a sporting spectacle turns fatal. Enlarged and washed out, the grainy quality of Peret's screen-printed body has a porousness bordering on dissolution, just as his musculature and facial features hew to some measure of solidity, his slack head held up by the white diagonal of the boxing ring rope.

To preface the short text written for the exhibition catalogue, Dittborn included a more legible screen print of the same image beneath a Gospel passage — Luke 23:53 — narrating the deposition and burial of Christ: 'Then he took it down and wrapped it in a linen shroud, and laid him in a rock-hewn tomb, where no one had ever yet been laid.'[120] Further shading the text and images that follow with a ghostly — to say nothing of divinely miraculous — cast, Dittborn's chosen verse is immediately preceded by Joseph of Arimathea's request for the body of Christ from Pilate, perhaps in an echo of more local pleas voiced by the Vicariate and the AFDD.[121] Yet Lihn saw no hope of recovery or resurrection in either the sporting or identificatory imagery, stressing that 'the boxer and the others are *damaged* subjects ...

[only] a "theatre mask" of success paraded before thousands or millions of failures'.[122]

While mostly in agreement with the drift of Lihn's analysis, Adriana Valdés — Lihn's partner at the time — struck a slightly more optimistic tone in her comments on 'Final de pista' in the Vicariate of Solidarity's bulletin *Mensaje*. Her text, which was aimed at a broader audience, pointed out how certain of Dittborn's works betray the mechanisms whereby we are not only categorised by the photographic apparatus, but also 'stereotype ourselves' with dreams and stock poses provided to us from elsewhere. That is, photography is both meant to identify and individualise and it is an index of our own fraudulent subjectivity.[123] Ultimately, Valdés's assertion is that Dittborn's work visualises mechanisms of oppression and alienation, producing nothing less than 'a Chilean amphitheatre of death and forgetting in a situation reiterated by history'; as such, his imagery should not be separated from the efforts of those working directly and explicitly to understand the present moment.[124]

While Jaar's own artistic labour was not the genre of 'work' Valdés meant to evoke in concluding, *Studies on Happiness* does purposefully dwell in the world. The open nature of the project uses the expanded field held in the complete work as a way not only to record the 'narrow margins' of freedom offered by one's stereotypical public face, but also force some internal recognition of those limits on the part of the audience and participants. *Studies on Happiness* is a work of portraiture at its core, yet specific phases engage more directly with the genre than others, particularly phases three and four, *Portraits of Happy and Unhappy People* and *Situations of Confrontation*. While Jaar would likely agree with the connotations of criminality and deviance that Kay ascribed to identity photos, his *Portraits* endeavour to show, in their photographic multiplication and use of bureaucratic formatting, precisely what such a genre of imagery cannot capture. The completed portraits of Agustin and Mirna (numbers 31 and 58 respectively) offer 20 photos of Agustin and 22 of Mirna, with the largest for each a 'neutral'-image betraying minimal expression. The smaller photographs of each interviewed subject — a paired grouping of posed 'happy' and 'unhappy' expressions, and then a series of contact images that appear

to move between posed shots with smiles or frowns and more candid imagery taken during conversation — suggest both the rigidity of posing — as Kay put it, 'one must remain *stiller than a photo*'[125] — and the limits of binary categorisation itself. Though Jaar was operating as the ultimate categoriser in naming individuals as happy or unhappy, the participants articulated the same themselves. Mirna acknowledged that 'happiness is the ideal put before us by culture, and the one to which we all tend, frustrating ourselves by not achieving it'.[126] Happiness, on this account, may be understood as a normative set of default choices — marriage, a 'good' job, children, religious faith, etc. — that, when opted for, should result in the elusive feeling.

The categorical rigidity gestured at in *Portraits* begins to unravel in *Situations of Confrontation*, where individual respondents are not only present alongside earlier recordings of themselves, but also speak, in an open forum, to questions posed by the audience, and to the fellow 'happy' or 'unhappy' individual sharing the stage. In so doing, *Situations of Confrontation* raises the issue of what happiness might mean in a culture of terror and silence, even if implicitly. To identify as 'happy' perhaps requires explanation, and maybe even a defence, just as the threshold of what might count as 'happy' could be radically variable. Yet, such utterances should not be confused with what feminist scholar Sara Ahmed has critically termed a 'hopeful performative': the operation of a positive psychology whereby repetition of the word can, perhaps, secure the feeling.[127] By contrast, Jaar's open forum and the simple fact of others being willing to talk honestly and directly about their lives, feelings and experiences — even if just in a small gathering for a short period of time — raises doubts about this ideal. Ahmed's writing resonates with the obliqueness of Jaar's questioning: '[I]f we do not assume that happiness is what we must defend, if we start questioning the happiness we are defending, then we can ask other questions about life, about what we want from life, or about what we want life to become. Possibilities have to be recognized as possibilities to become possible.'[128] In living under a regime that forced radical limits on what could even count as 'happiness', to have considered the term and the emotion could have allowed one to ask — even if just quietly, internally — what other alternatives might exist if one wished them to.

In addition to showcasing possible emotive states and their relative purchase on society, Jaar had to negotiate the possibilities of his inquiry and the form it would ultimately take. Describing the catalytic conjunction of Henri Bergson and Hans Haacke in developing the work, he has explained:

> *I went out and asked the most outrageous question you could possibly ask in the middle of the dictatorship. Dictatorship of course meant censorship and repression and you could be 'disappeared' if you crossed the line. But I thought this act would read as being so naïve that they were not going to touch me. That is how it was born. As this was a moment in time where you could not vote, there was no democracy: it became a platform for people to express themselves. As everyone was afraid like I was, they answered in very subtle ways, very oblique ways, they never said, 'I am against the dictatorship' — they couldn't, they were afraid. But it became a space of freedom, of resistance, a space of hope, because people were able to express themselves — somewhat — in the middle of the dictatorship.*[129]

While Haacke's various examples of polling from the early 1970s offered a distinctly conceptual language for mobilising a larger group of voices in relation to an individual artwork, the data-driven approach Jaar developed could have equally found form and example in the technocratic critiques offered by dissident intellectuals in Chile. In the aftermath of the coup and the institutionalised terror of military rule, elements of the left regrouped and attempted to formulate a forward-looking position from a range of privately funded think tanks, among them the Corporation for Latin American Economic Research (CIEPLAN), the Centre for Social Studies and Education (SUR) and the Latin American Centre for Research on Political Economy (CLEPI), which all received significant infusions of capital from abroad. '[F]oreign donors tended to value science more than ideology, and technocratic issues over theory', with the result that 'intellectuals went from being ideologues to being analysts'.[130] Not only was Jaar's questioning 'naïve', his presentation — from the polls on — spoke a language that the regime was willing, generally, to tolerate. As Latin Americanist

Jeffrey Puryear notes, 'until approximately 1980 the opposition could publicly critique the regime only on technical grounds. Political criticism was dangerous and unlikely to be picked up by the media even if attempted.'[131] Jaar, standing on a street corner or sitting on the other side of the interview table, cut the figure of a paradox: a long-haired artist type in clogs, but with carefully defined questions, categories of analysis and a precise-seeming methodology for data collection. And of course, mints.[132]

The tension between emotion and information, between feeling and data, as mobilised in *Studies on Happiness*, had been present in Jaar's practice since his very earliest works. Consider, for example, *September 11, 1973* (1974, fig.33), an austere calendar that is among the first objects in his body of work. The year 1973 is presented as white and red Letraset applied to a black background, with each month set in a regular grid, weekdays in white and Saturday and Sunday figured in red. The regular passage of time, however, is interrupted on 11 September, and all subsequent dates repeat the *11* of that tragic day — 'only eleven after the eleventh', as Jaar's notes have it on an initial sketch of the work still in the artist's personal collection (fig.34). In describing the impossibility of moving past the events of 11 September 1973, either by asserting the shadow of the coup over all that would follow or by being caught in a compulsive cycle of repetition, defining a present of anger, mourning or trauma, Jaar deployed the givenness of the calendar format to mark the impossibility of simply moving on. While a calendar is often a site of personalisation — dentist appointments, birthdays, anniversaries, vacations — the skipping, repetitive structure of Jaar's calendar forecloses such additive potential. His dates, held at *11*, are 'stupefied, paralyzed', in Adriana Valdés's words.[133] Directly related to the present discussion, in 'Objectos' ('Objects'), his first solo exhibition at Galería CAL in November and December 1979, alongside a range of sculptural works Jaar displayed a series of letter- and symbol-based self-portraits. Made in 1977 during his first trip to the United States, they use the American Standard Code for Information Interchange (ASCII) to picture the artist's alternately serious and anguished face as seen through a field of printable computer characters.[134] The exhibition flyer featured reproductions of a series of three self-portraits, in which Jaar appeared staring

straight on, then pushing his hair back and contorting his face, before finally facing the camera again, this time with lips parted, suggesting a cry or scream (fig.35, it also included instructions for a collaborative work by Jaar and Leppe). These dot-matrix likenesses, with their clear emotive arc articulated via an aggressively frontal and shallow pictorial space, fuse a body remade as symbol with the low-resolution, second-hand imagery that so fascinated Dittborn and Kay.[135] Though drawing on the clear language of images of the detained and disappeared, Jaar, of course, did not ask where he was, but perhaps what was left of him, or any human, when reduced to data points.

Even when considering all its phases as one, *Studies on Happiness* cannot be reduced to a series of statistics. Not only do its parts diverge in ways that privilege different modes of both response and collection, but its various presentations allow for both outward expression and interior contemplation. In capturing image and voice as much as in offering a place for either spoken speech or private thought, Jaar's work opens up to slippage and variance, to reconsideration and revision, or even just testing the waters. In providing his participants with a scenario that invited intimacy and the sharing of opinions, he might have caught them off guard, with circuits overrun. Rather than relying on a *silent* still image — magnetic for Kay as a space filled in some future-projective with the 'latency of other voices'[136] — Jaar encouraged his audience, as much as they were willing, to speak freely. Whether or not such a gesture could, in a climate of fear, overcome everyone's accrued social armour and palpable silences, or crack the façade of a blank face or stock phrase, it gave space all the same.

It took years for specialists to find a suitable critical language for the time; it was technical, couched in analysis, and as such rather obscure by nature. Yet, in everyday speech, on the street or at the market, people chose their words carefully. Such tentativeness well described the state of the Chilean media at the time. As the military regime attempted to pivot away from the state of siege that characterised the brutality of its first years, it loosened strictures on publishing and radio, and allowed for a guarded range of 'acceptable' voices to circulate, though they were still subject to state review and routine censorship. The publications *Mensaje, Solidaridad, Hoy* and *APSI* (*Agencia de Prensa de Servicios Internacionales*, or International Services Press Agency) had a combined circulation of about 120,000 copies and reached a readership at least triple that number.[137] The narrator of Fernández's *The Twilight Zone* recalls the mood of a couple of years later, in the mid-1980s, as 'a time of *Cauce* magazine getting passed from one person to another. It was a time of shocking headlines. A time of attacks, kidnappings, strikes, crimes, scams, lawsuits, indictments. A time of ghosts, too.'[138]

In December 1978, publications such as these played an essential newsbreaking role in the discovery of the bodies of fifteen peasants who had been buried alive in the lime kilns at Lonquén, a small town about forty

kilometres south of Santiago — an initial piece of hard evidence tying disappearances to government-ordered executions.[139] The legacy of torture and repression, even accounting for such instances of real journalistic and legal bravery, led to caution and tentativeness among the press and, of course, the public at large.[140] That said, people were being encouraged to speak and beginning to find their voices. In the aftermath of the Lonquén revelations, in August 1979, the month before Jaar began conceptualising *Studies on Happiness, Mensaje*'s editorial board published 'Lonquén: Hacia la recuperación del alma nacional' ('Lonquén: Toward the recuperation of our national soul'). The article diagnosed Chile to be a sick society that had lost its way in the fight for truth among 'labyrinths of lies and injustice'.[141] The editors asserted that 'the country needs to heal. But the only way is to open your eyes and face the truth, to restore justice and walk towards peace.'[142] In suggesting an essential tool toward a path forward, the editors closed by quoting the Jesuit Padre Alberto Hurtado, who founded the charitable organisation Hogar de Cristo (Home of Christ) to offer shelter and support to children in need in 1944, and who died in 1952, having founded *Mensaje* the previous year: 'In the face of opposition, there is a cowardly and easy posture: *silence*. There's a time for silence, but also a time to speak, *a duty to speak*.'[143] Though Padre Hurtado's urging came from another time, the use of his words carried significant weight in calling people together, and in urging readers to find their own voices among those of others as they followed the example of the journalists, lawyers and activists who had reported the Lonquén story.

Yet, just as Padre Hurtado articulated the duty of speech in the face of fear and opposition, the military regime, in advancing a new constitution that would enshrine a 'protected democracy', actively sought to curtail the possibility of free and open discourse. Describing the limits that the regime would ultimately impose on speech when the constitution was approved on 11 September 1980, one of its primary authors, Jaime Guzmán, framed his arguments around the need for community.[144] Writing in *Revista Realidad* in August 1980 without a shred of irony, Guzmán explained: '[W]e have already shown how ideological pluralism is inherent in the very differences that exist within a free society such as our own. But just as without difference,

fig.29

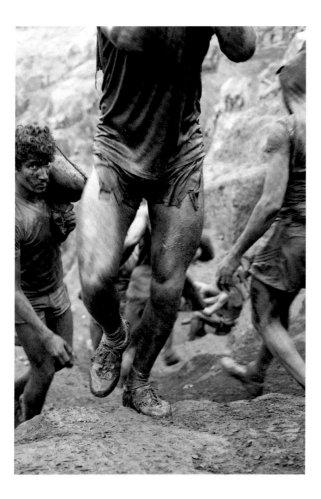

Alfredo Jaar, *Gold in the Morning*, 1985, photograph

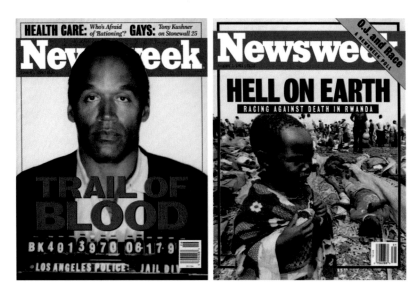

Alfredo Jaar, *Untitled (Newsweek)*, 1994, 48.3 × 33cm each

fig.32

Alfredo Jaar, *Real Pictures*, 1995, colour photographs
in silkscreen-printed archival boxes, dimensions variable

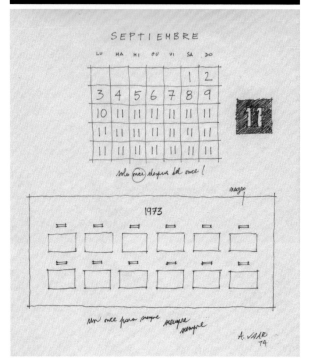

Above: Alfredo Jaar, *September 11, 1973 (Black)*, 1974, pigment print, 43.2 × 94cm
Below: Alfredo Jaar, *September 11, 1973 (Drawing)*, 1974, ink on paper, 21 × 15.9cm

fig.35

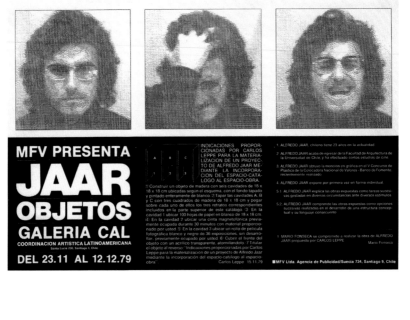

Exhibition flyer for 'Objectos', Alfredo Jaar's solo exhibition
at Galería CAL, Santiago, 23 November–12 December 1979

fig.36

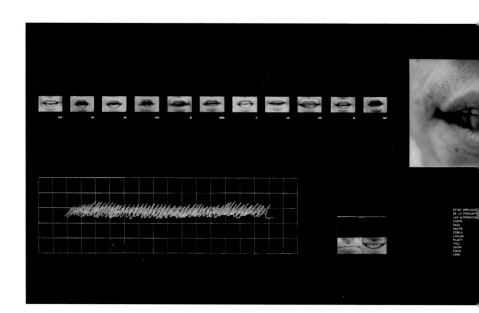

Alfredo Jaar, *Qué pasa con la plástica Chilena*, 1979, triptych

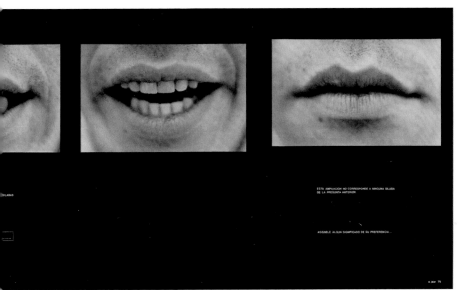

ESTA AMPLIACION NO CORRESPONDE A NINGUNA SILABA
DE LA PREGUNTA ANTERIOR.

ASIGNELE ALGUN SIGNIFICADO DE SU PREFERENCIA...

Alfredo Jaar, *The Skoghall Konsthall*, 2000,
public intervention, Skoghall, Sweden

there is no liberty, without a minimal level of consensus that is respected by everyone, community disappears … [and] when community disappears, obviously the possibility of having civil disagreements comes to an end.'[145] In an effort to promote 'freedom' and 'community', he continued, the new constitution 'suggests that we exclude from civic life those doctrines that attack the family, that promote violence, and, that support a totalitarian vision of society, the State and the legal system, or based on class struggle'.[146] Lest this appear too harsh, Guzmán quickly explained that 'it is not correct to say that this law would punish ideas, because in a person's heart of hearts, conscience is inviolate and sacred. It is not about the state getting involved in people's private lives, either, which would lead to an unacceptable "witch hunt". … [W]hat the proposed law specifically sanctions is the "propagation" of the specified doctrines, that is, their dissemination with intent to proselytize.'[147] For Guzmán, the potential suspension of basic rights was little more than collateral damage in the creation of a neoliberal society and economy 'founded on private ownership of the means of production and on individual initiative' above all else.[148]

Pinochet celebrated the implementation of the new constitution and the reopening of La Moneda palace with a parade on 11 March 1981. Proudly decked out in his military uniform and presidential sash, he rode standing in the 1966 Ford Galaxie given to then-president Eduardo Frei Montalva by Queen Elizabeth II. Yet clear pockets of dissent remained. University students only a couple years younger than Jaar were a 'glaring exception to the story of regime triumph and institutionalization'.[149] Various reforms — the promotion of technical fields over the humanities; tuition increases that limited access for the poor; the creation and accreditation of private institutions of higher learning — made advanced education less and less accessible to the wider population. The privileged often proved critical, however, and in brazen ways that included hunger strikes, sit-ins and other protests against the military rectors who controlled the universities. Such activities extended into calls for democracy more generally, including attempts to organise debates in the lead-up to the vote on the new constitution by the Restructuring Committee on the University of Chile Student Movement (CORREME) that included both pro and con positions. While

increasingly regular, such actions were still dangerous — especially given that the government-designated categories of threatening behaviour could be elastic, as when 98 young people were arrested for 'covert activism' at a folk festival in June 1980.[150] The classroom itself carried a chill of fear, as described by Enrique D'Etigny, a long-time professor and dean at the Universidad de Chile whom the military regime had relieved of his post. He offered a blunt assessment in July 1980 in a special issue of *APSI* devoted to student political thought: 'There is no possibility of free expression of thought, which is equivalent to the lack of the university. This is more visible the closer we get to the social sciences, and less visible the further we are from them. But though the expression of thought is prohibited, it exists latently [éste existe latente].'[151] Though sobering, D'Etigny's view held hope, as *latente*, in Spanish as in English, suggests a hidden presence, a reality waiting to manifest under the right conditions.

Latency proliferated in the art world, too, where the circle of artists, gallerists and writers was small. The military regime tolerated some avant-garde activity — its audiences were negligible as a segment of the overall population, and the art hermetic beyond its initiates — and focussed its efforts on the repression of folk art's more universally legible forms, including the sewn narrative panels known as *arpilleras* (fig.41). That said, to make critical art was not a risk-free endeavour by any means, and the danger increased the more legible the artist's position became.[152] Layering, doubling, allusion and omission were formal and discursive strategies employed by many, as much art — both on the walls and in print — likely passed by the censors because it was illegible to them. According to Valdés:

> The writing about art in catalogues, precarious supports not only in their materiality but also in circulation, happened hand-to-hand and photocopy-to-photocopy. A circuit with some amount of prestige was beginning to take shape among those who frequented it, though small and paradoxically clandestine. The works and writings had several registers. They could 'pass' in certain rather dangerous circles. They maintained an apparent smoothness, and behind that veneer the sub-understandings proliferated, the complicities, the ambiguities,

the 'saying one thing with another', if we can read 'thing' in a more
Lacanian and very threatening way: that of the absolutely repressed,
which cannot be articulated.[153]

Exemplary in this regard was *V.I.S.U.A.L. nelly richard rOnald kay dOs*
textOs sObre 9 dibujOs de dittbOrn (fig.48), released in October 1976. Styled
as an artist's book by Dittborn, this slim, self-published volume was printed
under the auspices of the Department of Humanistic Studies (DEH) at
the Universidad de Chile. Incorporating texts by both Richard and Kay,
it importantly inaugurated V.I.S.U.A.L. as a publishing endeavour between
Kay, Dittborn and Catalina Parra, with jarring text-image overlays that often
make simply reading — never mind understanding — the texts a bit of
a feat.[154]

Valdés's essay for Jaar's *An Open Work — A Non-Stop Record* could
not be any more different in design, even as its spiral-bound formatting makes
it of a piece with other artist's publications of the time. Foregrounding clarity
and simplicity, Jaar's small booklet contains Valdés's typed text and a final
summary page outlining the entirety of *Studies on Happiness*. With a nod
to latency, the text notes:

> Studies on Happiness, *in all its stages, builds on ground so commonplace*
> *as to be erroneously considered non-cultural. The questioning of*
> *happiness surfaces in daily lies; in advice from women's magazines,*
> *in advertising; in the fabrication of 'the tyranny of the offered object',*
> *which consciously manipulates the unconscious mechanisms of desire.*
> *Social conventions are not only those that are made explicit and*
> *presented in public, there are also those that dare not speak their name.*
> *This 'research' on happiness is situated on this slippery terrain.*[155]

Valdés stressed Jaar's working in the multiplicity of daily life — the street,
the news, TV — in an attempt to create a Marshall McLuhan-esque
'counterenvironment' where certain of the pervasive cultural assumptions
that govern life and comportment might be questioned.[156] As discussed
earlier, Valdés placed great weight on the social limits and stereotypical

presentations that Jaar's work laid bare, just as she described the setting for
An Open Work — A Non-Stop Record, and *Studies on Happiness* in general,
as an 'open work' par excellence, in that

> *the artist appeals to the manifestation of chance, by way of the
> participation or indifference of the public, unforeseeable up to the
> moment of the work's presentation. The careful preparation, the
> stages of the work, its arrangement — the concept behind any artistic
> performance — reach only a certain point in this work, namely,
> the creation of a framework, a system. Whatever happens from then
> on is uncontrollable. The game consists in creating a framework to
> induce actions that exceed it. The public's participation takes the place
> of chance, while the framework/system takes the place of necessity.
> A system created for inducing something that exceeds it, in pointed
> contrast to what is everywhere called 'the system', in which individual
> manifestations can only be seen as inconvenient and disturbing.*[157]

Individual participation would not exceed the work, as each of the formats
Jaar devised for engaging his audience was carefully designed to capture
most interaction. The disturbing excess, for Valdés, would come from squaring
self and image — from the uneasiness of sitting before a camera for as long
as one might choose to consider Jaar's questions, before perhaps leaving with
them. The excess would be imagining a world where an artist could, indeed,
rent a billboard and ask *¿Es usted feliz?* without fear, and consider the
texture of life in such a place.

Another way in which Jaar's work exceeded itself was through the
circulation of Valdés's essay, hand-to-hand and photocopied, like all else that
moved through the Chilean art world at the time. The seven-page text
was printed at a local Copimart, with no more than a hundred copies likely
produced, and Jaar kept a meticulous list of who received — or at least
to whom he sent — the comb-bound pamphlet (fig.27). At this point in his
career, he was working to break into the scene, and this text, by a major
critic, carried real currency. Written in block capital letters betraying
an architect's hand, the list reads like a who's who of the Chilean art world,

including artists, historians, journalists and museum professionals (Ronald Kay being a notable absence, though he had returned to Germany by this point). Certain inclusions — the 'niñita' (little girl), 'pintor Español' (Spanish painter) and two 'estudiantes UC' (Universidad de Chile students) — suggest that this list tracked the ultimate destination of every copy Jaar had, rather than simply naming to-be-gifted texts destined for friends and networking. Valdés herself tops the list, with an allotment of five copies; Lotty Rosenfeld and the playwright Benjamín Galemiri each got two; and Dittborn, Leppe, Donoso, Adasme, Richard and everyone else, just one.[158] Thus, the essay itself, as a material object in circulation, functioned as something of an open work, its distribution a mode of connection and dialogue within the Chilean art scene, and Jaar's attempt to have his voice heard in the conversation at this moment.

Yet, not everyone was there. Cecilia Vicuña, the sixth name on the list
of delivered texts, had been living in Bogotá, Colombia in self-imposed exile
following her British Council-funded postgraduate study at the Slade School
of Fine Art in London from 1972 to 1975.[159] Jaar, who had heard Vicuña's
name mentioned in Santiago, mailed her a copy of Valdés's essay, which she
unfortunately never received.[160] Though both Vicuña and Jaar were
associated with some of the collaborative performances of CADA, what's
more to the point is the family resemblance of their work in 1980, unknown
to each at that point in time.[161] Equally poet and visual artist, Vicuña filmed
a roughly twenty-minute film in 1980, *¿Qué es para usted la poesía? (What
is Poetry to You?*, fig.50). With the help of a small cooperative formed to
undertake the project, she interviewed people in and around Bogotá, asking
them their views on poetry.[162] Though the shooting was completed in a
matter of weeks, technical problems with the sound kept the film from being
shown for nearly twenty years; it eventually debuted in 1998, once Vicuña
had secured the necessary funding to complete it.[163] No 'rough' material ever
circulated and no mention of this work would have been available to Jaar
in Santiago. Yet the artists' parallel practices reveal a kindred commitment
to a certain multiplicity of voicings and the distinct realities held in them.

Vicuña's project unfolded rather differently than Jaar's. Even as
the filming wrapped quickly, the documentary continued an unfinished work
undertaken in Chile in the late 1960s and early 1970s, for which the artist
began calling every person listed in her local telephone directory to note down
their comments on poetry in a notebook.[164] Vicuña hoped to listen to as
many people as possible, fascinated by oral culture and the liberatory function
of everyday language — a lifelong interest first triggered by her exposure
to the cadences captured in Cuban anthropologist Miguel Barnet's chronicling
of the life of Esteban Monejo in *Biografía de un cimarrón (Biography of
a Runaway Slave*, 1966).[165] When she took up the idea again in 1980, her scope
had narrowed and she began to plan a shorter project that would enlist a
range of artists of all kinds, including the Colombian singer Totó la Momposina.
After failing to secure the participation of her desired performers, Vicuña
settled on a more documentary format, with a variety of subjects, including
tradesmen, professors, unhoused individuals, police officers, prostitutes,

community organisers, school children and club-goers, among others. Some of her subjects were known to her and her collaborators; many were not.

The film begins dramatically with a quotation from the German Romantic Novalis — 'poetry is the first religion of humanity' — and pans atop the Cerro de Guadalupe outside Bogotá before attending to the work of conversing. Front and centre, with a microphone throughout, Vicuña appears to give her interviewees the space to consider a form of writing thought to be at a slight remove from the concerns of everyday life, even as, in her questioning, she engages with the poetics of the quotidian. Though most replies are short, and often a bit canned — '[poetry is] a wild animal that converts its song into a cry for freedom', runs one offered at the Salsatheque Pagan Pleasures and likely lubricated by some drink — Vicuña's belief in the power of poetry as a form of committed action comes through clearly in her attentive listening. At a certain point, interviewing residents of the communist community in Barrio Policarpa, where she knows her subjects, her prompt changes from 'What does poetry mean to you?' to an invitation to 'talk … about words as weapons of organisation'. Such phrasing found plastic form in Vicuña's contemporaneous series of hybrid works *Palabrarmas* (*Word Weapons*, 1966–, fig.51), where image and text are interlaced to create new meanings in and through the fusion of common words. It also suggests that to ask strangers about poetry, just like happiness, is to create space to think about worldly possibilities, in the here and now of the questioning, a bit differently.

Though united by their overarching interrogatives, Vicuña's and Jaar's projects also differed significantly in structure. The one developed as a relatively straightforward documentary; the other as a series of interconnected parts, each with a different tack, that circled a variety of performative actions and their associated forms of documentation. In an element absent from Jaar's project — at least explicitly — Vicuña used her format to unite a range of socioeconomically diverse viewpoints around her inquiry. Though portions of Jaar's work took place on the street, at sites of nominal social mixing, the project occurred mostly in the city centre and at various exhibition venues, eclipsing the *poblaciónes* ringing Santiago and its poorer residents. The streets are lively in *What is Poetry to You?*,

and Vicuña's question, even as personal views on poetry open onto wider social issues, does not carry the implied weight that asking about individual happiness in Chile at the time would.

A powerful analogue can be found in Vicuña's more morphologically distinct work *Otoño* (*Autumn*), an installation completed in June 1971, of a large quantity of fallen leaves at the Museo Nacional de Bellas Artes in Santiago, which the artist 'conceived as a contribution to socialism in Chile'.[166] Vicuña collaborated with friends, family and gardeners to gather leaves from the city's public parks and wooded areas for delivery by the bag- or truckful at the museum's entrance. From there, the artist, with the help of her mother and friends, pushed them into the building. Vicuña recorded the last-minute events of the opening day in her journal:

> *3 lorries loaded with leaves coming from the second park unload*
> *at the museum door. together with my mother and some friends we push*
> *them into the museum. it takes us all day to do it and we have to cover*
> *ourselves with sheer cloth to protect our eyes while swimming in the*
> *leaves. we push with our bodies, with long sticks, with whatever we find.*
> *finally the room is filled with leaves one hour before the opening.*
> *when the rest of my friends arrive it looks like an ocean of leaves a meter*
> *deep at the entrance gently sloping down to 10 cm deep. there are*
> *also 25 plastic bags (cloth size) and 2 (mattress size) full of leaves.*
> *people laugh very much. there are no photographs and no documents*
> *of this piece.*[167]

Resonant with much conceptual and earth art being made at the time — though Vicuña only learned of 'conceptual art' when the museum's director, Nemesio Antúnez, described the work as such in a radio interview — *Autumn*, as the laughter noted above suggests, was not well received at the time.[168] However, CADA's members, who met with Vicuña when she was visiting Chile in either 1978 or 1979, retrospectively recognised its importance and described it to her as among the only viable precedents for their work in Chile.[169] Indeed, there is a strong formal resonance to be found in *Autumn*'s use of delivery trucks and CADA's own marshalling of milk trucks as part

fig.39

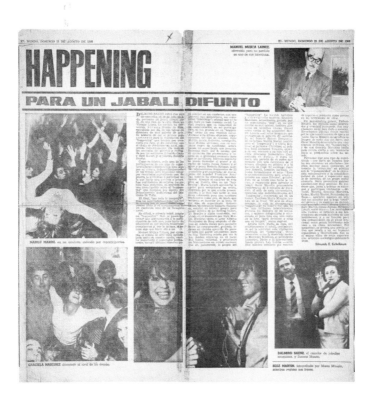

Roberto Jacoby, Eduardo Costa and Raúl Escari, *Happening para un jabalí difunto*,
newspaper clippling from *El Mundo*, 21 August 1966. Courtesy Roberto Jacoby and Archivos en uso

fig.40

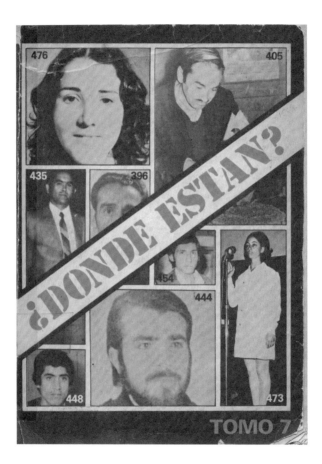

Cover of *¿Dónde están?*, Tomo 7, May 1979. Courtesy Fundación
de Documentación y Archivo de la Vicaría de la Solidaridad, Santiago

fig.41

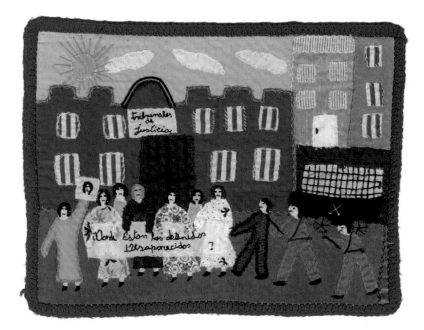

¿Dónde están los detenidos desaparecidos?, 1979, anonymous arpillera,
hand-embroidered and quilted textile, 36.7 × 49cm. Collection of Marijke Oudgeest.
Courtesy Museo de la Memoria y los Derechos Humanos, Santiago

fig.42

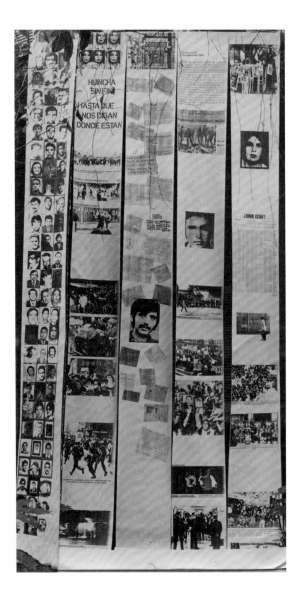

Luz Donoso, *Huincha sin fin*, 1979, black-and-white photographs, dimensions variable. Luz Donoso Archive.
Photo: Luz Donoso, Courtesy Jenny Holmgren and Paulina Varas

fig.43

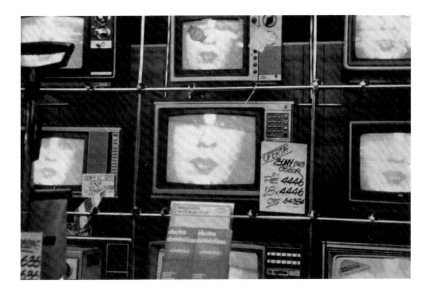

Elías Adasme, Luz Donoso, Hernán Parada and Patricia Saavedra,
Acciones de Apoyo: Intervención de un sistema comercial, 1979, documentation. Luz Donoso Archive.
Photo: Luz Donoso, Courtesy Jenny Holmgren and Paulina Varas

fig.44

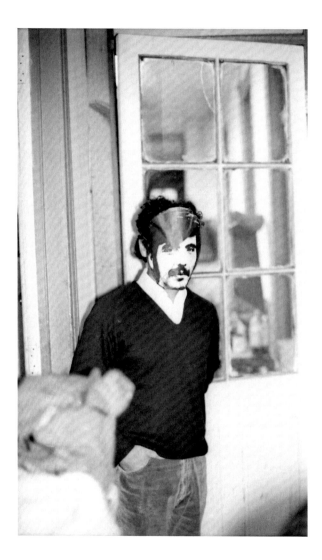

Hernán Parada, *Acción con mascara en presentación de Obrabierta*, 1974–, Taller de Artes Visuales, Santiago, November 1984. Photo: Luz Donoso and Patricia Saavedra, Courtesy the artist

fig.45

OBRABIERTA "A"
START DATE:30 JULY 1974 — END DATE:?

FACTS ABOUT "A"
NAME: ALEJANDRO ARTURO PARADA GONZALEZ
AGE: 22 SEX: MALE
OCCUPATION: VETERINARY STUDENT, UNIVERSIDAD DE CHILE
MARITAL STATUS: MARRIED

KNOWN DEVELOPMENTS IN SPACE-TIME FOUNDATIONAL TO THE WORK:
FROM 8 JANUARY 1952 (08:05 AM) — TALCA, CHILE
TO 30 JULY 1974 (3:30 AM) — SANTIAGO, CHILE

FROM THIS POINT AND FOLLOWING, THE INABILITY AND UNCERTIANTLY OF
BEING UNABLE TO LOCATE AND/OR KNOW THE WHEREABOUTS OF "A"
PROVIDES THE RATIONALE IN THE DECLARATION OF AN "OPEN WORK" OF A
RELATIVISTIC NATURE AND NON-CONFORMING TO OUR KNOWN SPACE-TIME.

STRUCTURE OF THE WORK:
AS A CENTRALIZED HOUSING: ALL DOCUMENTATION AND INFORMATION
GENERATED AND PRODUCED BY "A" UNTIL 30 JULY 1974. AND FOLLOWING,

AS A SITE OF FEEDBACK: ALL NEW INFORMATION RELATED TO "A"
OBTAINED THROUGH ANY ACTION.

CONCLUSION/END OF THE WORK:
ON THE SPECIFIC DATE THAT THE SITUATION "A" IS
RESOLVED-CLARIFIED. MEANWHILE, ALL VARIANTS MUST BE UNDERSTOOD
AS INTEGRAL PARTS OF AN ARTWORK IN PROCESS.

BACKGROUND:
"PROPOSICION Y DESARROLLO TESIS OBRABIERTA" (1978-1980 ESCUELA
DE BELLAS ARTES, UNIVERSIDAD DE CHILE)

MODEL APPLICABLE TO ALL CASES OF THE DETAINED-DISAPPEARED.

PRESENTATIONS: 1978, 1979, 1982, 1984, 1985, AND SINCE 2008.

UPDATED/TRANSLATED: MAY 2023, TORONTO, CANADA

HERNAN ALBERTO PARADA GONZALEZ

Hernán Parada, *Proposición Obrabierta 'A' (texto)*, 1 October 1978, with subsequent additions.
Courtesy the artist. Translated from the Spanish by Hernán Parada and Edward A. Vazquez

fig.46

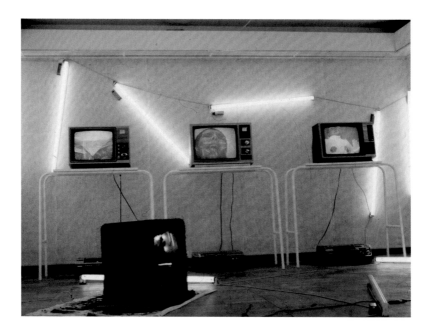

Carlos Leppe, *Las cantatrices (video acción)*, 1980. Installation view, 'Sala de Espera', Galería Sur, Santiago. Carlos Leppe Archive. Courtesy D21 Proyectos de Arte

fig.47

Page spread from Eugenio Dittborn, *Final de pista*, 1977, artist's book and exhibition catalogue published by V.I.S.U.A.L./Galería Época, Santiago, 33 × 22cm. Courtesy the artist and Marquand Library of Art and Archaeology, Princeton University

fig.48

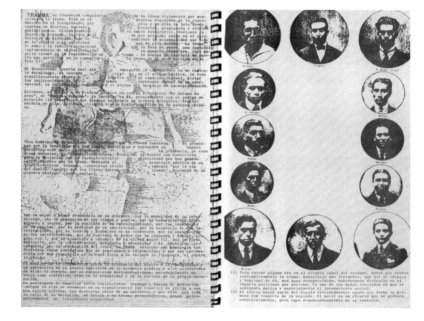

Page spread from Eugenio Dittborn, *V.I.S.U.A.L. nelly richard rOnald kay dOs textOs sObre 9 dibujOs de dittbOrn*, 1976, artist's book and exhibition catalogue published by V.I.S.U.A.L./Galería Época, Santiago, 33.5 × 22cm.
Courtesy the artist and Marquand Library of Art and Archaeology, Princeton University

fig.49

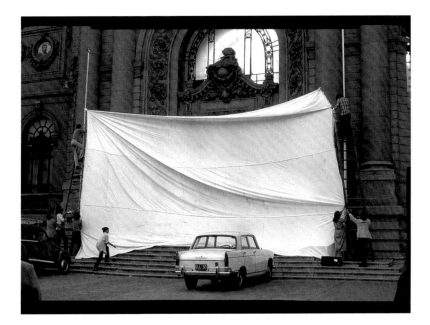

CADA, *Inversión de escena*, 1979, photograph,
30.5 × 40.5cm. CADA Archive Collection. Courtesy Fundación Lotty Rosenfeld
and Museo de la Memoria y los Derechos Humanos, Santiago

fig.50

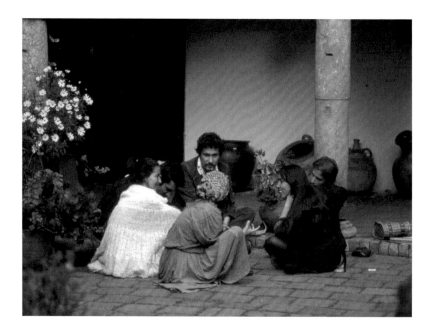

Cecilia Vicuña, *¿Qué es para usted la poesía?*, 1980, 23:20min,
16mm film transferred onto video, with sound, Spanish with English subtitles. Courtesy the artist

fig.51

Cecilia Vicuña, *Palabrarma*, 1974, collage. Essex Collection of Art
from Latin America. Photo: England & Co Gallery, London, Courtesy the artist

fig.52

Cecilia Vicuña, *Frente Cultural*, 1973, oil on canvas. Private collection.
Photo: England & Co Gallery, London, Courtesy the artist

fig.53

Me llamo Raquel
estoy en el oficio
desde hace varios
años. Me encuentro
en la mitad de
mi vida. Perdí
el camino. —

EGO SUM | QUI SUM

Page spread from Raúl Zurita, *Purgatorio*, 1979,
published by Editorial Universitaria, Santiago. Courtesy the artist

fig.54

Page from Raúl Zurita, *Purgatorio*, 1979, published
by Editorial Universitaria, Santiago. Courtesy the artist

of their action *Inversión de escena* (*Scene Inversion*, fig.49) on 17 October 1979, as both works stress the importance of sites exterior to the museum itself, albeit under radically different circumstances. In CADA's work, milk trucks were used to temporarily block access to the Museo Nacional de Bellas Artes as a large white sheet hung over the main entrance. While the unauthorised action extended CADA's use of milk earlier in 1979, in *Para no morir de hambre en el arte* (*Not to Die of Hunger in Art*), the billowing fabric barrier asserted that the art — or culture — worth considering was taking place in the street rather than within the confines of a state-run museum.[170]

Regardless of *Autumn*'s original reception and later resonances, Vicuña had meant to cue a rebirth and expanded awareness:

> *politically people could find it more and more necessary to create
> and fight for a world where everyone could get turned on by reality.
> this room wants to give joy. art was born for playing and though people
> may have forgotten, it is time that they remember. joy is a necessity.
> working on my autumn piece i experienced joy. working on my joy
> i experienced autumn ... joy could make people aware of the need
> to fight for joy.*[171]

In 1971, such a work could stand in solidarity with the revolution underway in Chile, expressing the need for joy and, ultimately, a total rebirth, as cued to an aesthetic and perceptual connectedness to leaves and, by extension, the world. Ten years later, though joy was not foreclosed, Jaar did not ask after happiness in order to assert its liberatory potential. Much more in line with CADA's aggressive blankness, he named something to mark both its fundamental importance and its equally overwhelming absence — as he would do to more dramatic effect with his later work *The Skoghall Konsthall* (2000, fig.37, 38). In Sweden, working on site in the industrial town of Skoghall, Jaar responded to the lack of a local art space by building a temporary kunsthalle out of paper, in which he mounted an exhibition of local artists before ceremonially burning the structure down 24 hours later.[172] Two decades earlier, in Chile, he had asked about happiness as a way to mark its limited

reach: to pause over a social contraction and national muffling, and — perhaps less obliquely than Vicuña's leaves underfoot in a museum — to assert the need to remember, be aware and fight.

In 1973, Vicuña made a painting called *Frente Cultural* (*Cultural Front*, fig.52), with the titular phrase spread across the brow of a distortedly ethereal being, punning on the meaning of front and forehead. Completed in London before the coup in Chile, Vicuña's painting shows a floating sphere of interconnectivity across sectors of cultural and material production, all in the service of revolution. With references to Cuban-Chilean solidarity, Che Guevara and Allende's attempted education reform through the Escuela Nacional Unificada (National Unified School, ENU), alongside mural painting (the slogan 'To increase production is also revolution' inscribed on a wall), writing, film, music and industrial as well as agricultural labour, the painting's soft pink palette conjures an orb, perhaps a womb, of open experimentation and collective effort that would become impossible by 1980. Impossible, though not unimaginable, even if with different tools and reference points.

In Jaar's case, his intellectual formation with respect to the role of cultural production can be traced to his exposure to the Italian Neo-realist cinema of Roberto Rossellini and Vittorio De Sica through a course at the Instituto Chileno-Norteamericano de Cultura in 1978, which led him to the films and writings of Pier Paolo Pasolini. Jaar discovered in Pasolini a poet and thinker with whom he felt a deep connection; he was particularly drawn to Pasolini's poem 'Le Ceneri di Gramsci' ('The Ashes of Gramsci', 1954, published in 1957), which the young artist would have read in translation. This, in turn, led him to engage with the ideas and writings of the Italian Marxist and political theorist Antonio Gramsci, whose work he was exploring in some depth by 1980.[173]

In 'The Ashes of Gramsci', Pasolini pays a visit to the Non-Catholic Cemetery in Rome, where Gramsci's ashes rest, and he voices a tension between the emotional and intellectual, famously writing of

> *The scandal of self-contradiction — of being*
> *with you and against you; with you in my heart,*
> *in the light, against you in the dark of my gut.*[174]

This description of the aporia of the individual caught between ideals and passions dilates into a generational appraisal on the loss of political

commitment in the post-War moment.[175] As the poem ends, and the poet leaves the cemetery in the Testaccio, he conjures images of the working-class lives below, of the whir of garages and the blood of slaughterhouses:

> *Life is commotion; and these people are*
> *lost in it, and untroubled when they lose it,*
> *since their hearts are full of it. There they are,*
>
> *poor things, enjoying the evening, helpless;*
> *yet in them and for them, myth is reborn*
> *in all its power… But I, with the conscious*
>
> *heart of one who lives only in history,*
> *can I ever act with pure passion again,*
> *when I know that our history has ended?*[176]

The poet thus descends into the vitality and churn of everydayness, but does so in pessimistic acknowledgement of the distance between the working class and his own intellectual position, lamenting a moment or even an epoch, as film scholar Maurizio Viano has put it, 'when the proletariat prefers television to revolution'.[177] Yet, faced with Pasolini's words, Jaar — and the poet, too, in his way — refused total pessimism. 'It is important to insist', Jaar has since offered, in a Gramscian vein, 'that culture can effect change.'[178] Indeed, Jaar's entire artistic output, in its clear and measured responses to the givenness of social realities and their attendant atrocities, can be understood via a Gramscian maxim that the artist has, in a certain sense, taken as his own: 'Every collapse brings along intellectual and moral disorder. It is necessary to create sober, patient people who do not despair in the face of the worst horrors and who do not become exuberant with every silliness. Pessimism of the intelligence, optimism of the will.'[179]

Though the path Jaar describes of arriving at Gramsci cuts a rather straight line, the political theorist's reception in Chile has been complex. In the moments of possibility that led up to, and culminated in, Allende's electoral victory in November 1970, few dismissed the importance of

the Italian thinker, even as his writings — many of them famously penned in prison during Benito Mussolini's dictatorship — seemed a missive from a dark and distant time. Thus, when selections of Gramsci's prison notebooks were published in a Chilean edition in 1971, he was lauded as an anti-fascist warrior on terrain far different from the Chilean experiment in socialism then underway.[180] Once Pinochet took power, and Gramsci's writings became lamentably topical, they were difficult and dangerous to find, though by the late 1970s Gramsci's ideas were beginning to circulate more actively. Indeed, in April and December 1979 — dates that overlap with Jaar's period of research and conceptualisation of *Studies on Happiness* — two lengthy articles introducing Gramsci's ideas in relation to Marxism and culture to a general readership were published in *Mensaje*; both were authored by Juan Eduardo García-Huidobro, writing under the pseudonym of Tomás Valdivia.

The first article begins with Gramsci's expansion of the concept of the state, and describes the complex relationship of political and civil actions that allows the ruling class not only to remain in power, but also to obtain the active consent of those being governed. In Valdivia's summary, 'the distinction between politics and civil society is a "methodological distinction" and it is a "theoretical error" to transform it into an "organic distinction".'[181] The analysis then moves to what the author sees as the fundamental novelty of the Gramscian perspective: the valorisation of civil society and cultural activity, and the fluid and interwoven articulation of power in hegemonic relationships. Hegemony, broadly defined, is the sociopolitical operation — or ideological magic trick — whereby the interests and goals of a certain (ruling) class are adopted by subordinate groups as their own and understood as in their interest.[182] Hegemony operates in spaces of freedom and choice, maintaining 'a conception of the world and of society that makes sense of the economic and political' projects of the ruling class, and, in presenting such views as culturally common, creates a false ground where contested premises of living and governing are accepted and normalised.[183] Hence, all hegemonic operations are pedagogical ones, and all culture serves to define a field of common sense.[184]

Building on this overview, the second article explores the different ways in which a 'war of position' can be fought on cultural fronts, as an active

and explicit response to the 'official' culture of the ruling class. It is Valdivia's assertion that, according to Gramsci, all humans are philosophers and all forms of life offer potentially alternative ways of thinking and being, particularly through folklore, even as people are also conformists who may simply carry the assumptions and dispositions of their time and place. He claims that everyday philosophy, in and as culture, is a sociohistorical fact, and, further, that 'to know oneself is equivalent to knowing history, to reading it, interpreting it'.[185] Folklore — and the common senses that it crystalises across subaltern populations — is multiple, messy and even contradictory, whereas dominant culture has been distilled, systematised and elaborated as hegemonic form by the ruling classes. A true philosophy of praxis is one that arises from the organic expressions of the subaltern, which is where the project for an alternative culture develops. Though for this project to be legible as such, it must overcome the natural splintering of the subaltern through a clarity of message 'whose point of departure is the masses and whose terminus is those same masses'.[186] Valdivia goes on to discuss Gramsci's articulation of the role of intellectuals acting as translators, in the sense that they both understand the people and synthesise, abstract and make intelligible what otherwise operates diffusely across a range of cultural forms. 'The characteristics of this union of the masses and intellectuals allows the philosophy of praxis to be a synthesis of high culture and popular culture'.[187] In clearly articulating a culture *of* the people rather than something imposed upon them, intellectuals 'elaborate the new culture' in the formation of a coherent sociocultural bloc.[188]

Jaar was unaware of Valdivia's texts, but, as a reader of both Pasolini and Gramsci around the time of their publication, he certainly considered the stakes of the artist/intellectual and their ability to reframe a conversation, or just open a space, for that potentiality. His choice of happiness was 'naïve' and untouchable, and at the same time it cut to the core of certain assumptions about what we all might want from life, from a form of life.[189] If happiness, in Chile's official culture around 1980, meant private property and a rugged, neoliberal individualism, then Jaar, to use Marxist cultural theorist Raymond Williams's formulation, helps us 'to recognize the alternative meanings and values, the alternative opinions and attitudes,

and even some *alternative senses of the world*, which can be accommodated and tolerated within a particular effective and dominant culture'.[190] Williams argues that any rigorous analysis must confront artworks as practices rather than objects, because

> *[t]he relationship between the making of a work of art and its reception is always active, and subject to conventions, which in themselves are forms of (changing) social organization and relationship, and this is radically different from the production and consumption of an object. It is indeed an activity and a practice.... [W]e have to break from the common procedure of isolating the object and then discovering its components. On the contrary we have to discover the nature of a practice and then its conditions.*[191]

To see through the scrim of convenient objecthood onto a dynamic interlacing of relationships is Williams's critical charge in writing; Jaar's, however, was an artistic one that he well described at the time. In a lengthy interview given in 1982, when asked about the political implications of his practice, Jaar spoke against the static object and in favour of the complex weft of experience an artwork might hold:

> *I believe in art as a detonator of collective consciousness.... I believe in art's capacity to influence, truly and profoundly, the life of a society. Art isn't, as some say, 'Art reflects the expressions of a people and of the society in which we live.' There's a lot of that, but it also has the capacity to influence ... it produces a* feedback. *It's a constant game of coming and going. The work draws on social situations, but society also draws, can be changed by, this constant questioning, these ruptures, these transformative intentions.... So many things!*[192]

Not only does Jaar clearly present his motivations, but he also well characterises the fluidity of the cultural field and its complex play of overlay, exchange and adjustment between all that defines an artistic practice and informs its conditions. The language of feedback describes this dynamism,

just as it is formally specific, too, in relation to his use of televisual capture.
If, as Gramsci asserted, 'every individual carries on some intellectual activity:
he is a philosopher, he shares a conception of the world and therefore
contributes to sustain it or to modify it, that is, to create new conceptions',[193]
then Jaar has sought to give each philosopher a space of enunciation,
held in the flexible format of his *Open Work*, and a place to see whether
or not their pronouncements stand out of phase with themselves, as data,
in photographs, potentially hailed from a billboard or just as seen on TV.

The social role of Jaar's artistic brief was quite clear to him by 1981, but the work that had immediately preceded *Studies on Happiness* played it a bit more tightly, with its stated reference being the art world itself. *¿Qué pasa con la plástica Chilena?* (*What's going on with Chilean art?*, 1979) mobilised the titular question as something of a critique of the state of Chilean art. It won an honourable mention at the Quinto Concurso Colocadora Nacional de Valores (Fifth Salon sponsored by the Colocadora Nacional de Valores), a juried show at the Museo Nacional de Bellas Artes. *What's going on with Chilean art?* offers a document, game and prompt, all housed within a triptych format that reads left to right (fig.36).[194] In the leftmost panel, a series of eleven closely framed photographs picture lips in motion, with the whiteness of teeth ebbing and flowing against the mouth's darker recesses depending on the elocution. Jaar's captions pair the images with syllables, such that every photograph corresponds to one syllable of the work's titular question. Spaced evenly across a black field, the photographs rest above a rectangular grid of five rows by eighteen columns that appears to translate the language presented above into peaks and valleys that evoke the acoustic read-out of a sonograph. This grid stands to the left of two additional photographs of the same mouth — smiling and frowning — that push outward into space, as they are affixed to a box-like construction that sets them apart from the rest of the work. The central panel repeats two of the left panel's eleven photographs, dramatically enlarged and set above an imperative: 'These enlargements correspond to two syllables of the previous question. Find them. The options are…'. It seems that the enlargements correspond to the ninth ('chi') and first ('que') photographs respectively, though Jaar's list of possible options blurs and combines the captions of the rightmost photographs, such that the regular and syllabic breaks of que|pa|sa|con|la|plas|ti|ca|chi|le|na that define the series become

QUEPA
PASA
SACON
CONLA
LAPLAS

PLASTI
TICA
CACHI
CHILE
LENA

Including two syllables for each option and doubling the second syllable
of each as the first of the next, the given choices suggest, at the level
of form, the impossibility of the task at hand.[195] The final panel holds a single
enlarged photograph of the same mouth, again cropped and now closed.
Beneath this image, a text urges the viewer to consider and attach meaning
to the silence evident in the image: 'This enlargement does not correspond
to any syllable of the previous question. Please assign it a significance of
your choosing.'

Part tongue-in-cheek game, part photographic progression, the work
requires any viewer playing along to occupy distinct positions relative to the
photographs. Initially, with the matching of images, we perform a rudimentary
process of lip-reading. Connecting parts of an ephemeral vocalisation
to the static visual documents arranged in sequence, in effect we reattach
a fleeting moment of enunciation to a fixed record of its external manifestation.
In the last image, Jaar proposes something altogether different: to ascribe
some meaning to the absence of speech; to read the closed lips of the
photographic subject as privately and uniquely important, their transmission
of significance as variable as the thoughts anyone might choose to attach
to them. If the first of these operations mimics a type of detective work
associated with the controlling vision of surveillance, then the second speaks
through the traces of its own silence, either as an index of freedom or
a measure of the constraints of a social mask — or, more likely, as a fluid
articulation of both.

As a carefully composed sequence, everything in the work refers to its
titular question, whether as direct transposition, scrambled reference or
purposeful abstention. The protruding smile and frown offer the exception
in this otherwise tightly self-referential work. Presumably they offer
judgement, either affirmative or negative, on the state of the Chilean art

scene: a supporting smile or a dour, critical frown. Yet the smile and frown could also stand as the poles through which we often interpret the neutral-seeming mouth in the work's third panel, assigning some significance to an otherwise 'blank' mouth, shading it in one affective direction or the other. That the smile/frown pushes out into space might also reference the viewer and their reaction to this (or any) work. More to the point: this small protrusion offers the germ of *Studies on Happiness*. As an intervention outward into real space — even if held in a sort of high relief — it anticipates the language of emotion, bluntly marked as upturned or downturned lips, that Jaar would consider in his subsequent project. Even though the protruding box is not an interactive place to register discontent or happiness relative to the titular question, it pushes against the world, against social space, raising a question, perhaps not about the state of Chilean art, or even happiness, but about mood and affect in the surrounding world.[196]

Such issues were of central importance to Jaar's friend Raúl Zurita, a member of CADA who in 1979 — the year of *What's going on with Chilean art?* — published one of the most important poetic responses to the dictatorship: *Purgatorio* (*Purgatory*), the first part of a Dantean trilogy that would also include *Anteparaíso* (*Anteparadise*, 1982) and *La vida nueva* (*The New Life*, 1994). Zurita's work is a complex collage that moves between masculine and feminine subject positions as well as meditations on the Chilean desert, non-Euclidian geometry and the suffering of a cow, in what the poet has described as learning 'to speak again from total wreckage'.[197] Its opening and closing passages amplify aspects of Jaar's contemporaneous project.

The poem begins with an affective declaration — 'my friends think / I'm a sick woman / because I burned my cheek'[198] — recoding, in the feminine, Zurita's earlier act of self-harm when, in 1975, he burned himself with a red-hot knife. Set as a block of uniform, justified text, the regularity of the spacing contrasts with the decisive stroke of violence described and the anguish leading to it. Dedicated to Diamela Eltit, the next spread reproduces a photocopied ID photograph of Zurita with his right cheek bandaged, which would have been at home among the imagery of Dittborn's 'Final de pista' exhibition; alongside the ID, a passage of handwritten text reads,

'My name is Raquel/I've been in the same/business for many/years. I'm in the/Middle of my life./I've lost my way. — '[199] Text and image are joined by the heavily stencilled phrase 'Ego Sum Qui Sum' (I am who I am) — God's self-description to Moses from Exodus 3:14 — symmetrically placed across the pages' gutter, where it suggests both the multiplicity of the speaker and the overlapping identity of Raúl/Raquel (fig.53). The margins of the handwritten note conform exactly to the border defined by the grey space surrounding Zurita's photograph, further defining a congruence — or dissonance — and linking the degraded image of the author to Raquel's personal note and opening space of affective self-description.

Zurita returns to the cheek in the poem's final section, titled 'La Vida Nueva', where, across three Dantean pages, he writes:

> *INFERNO/my cheek is the shattered [estrellado] sky/Bernadette/*
> *PURGATORY/my cheek is the shattered sky and the broth/els of*
> *Chile/Saint Joan/*
> *PARADISE/of the love that moves the sun and other stars/My*
> *Friends and I/MY STRUGGLE*[200]

These lines are centred atop a reproduction of an electroencephalogram (EEG, a graphic transposition of electrical activity in the brain), with three jagged lines above and below the text (fig.54). As Zurita's speaker returns to the site of trauma announced in the poem's opening lines, the cheek comes to function as an all-encompassing landscape: both the sky above and the housing for movements both corporeal and celestial. The skitter of the EEG also suggests varied terrain — whether oceanic crashes, Andean evocations or seismic rumblings — that symmetrically frames the text and its world-encompassing pronouncements. The medical record returns us to the naming of sickness in the opening lines, as well as to the inclusion of a psychiatric evaluation of Zurita embedded earlier in the poem that refers to the clinical use of such tests in assessing a patient's 'epileptic psychosis'.[201] As a wavering field of data and diagnostics, and an evocation of electricity in, on and through the body, the EEG read-out speaks to more than just the currents of brain impulses.

What catches my attention, however, is the morphological similarity between Zurita's EEG and Jaar's sonographic markings on the first panel of *What's going on with Chilean art?* Concluding a poem self-consciously fashioned of ruins, the EEG stands as one more fragmentary piece of the damaged speaker, its lines suggesting the jagged articulations offered by scientific knowledge of the inaccessible interiority of the poet's mind, the totality of thought and feeling as carried by electrical impulses transposed into read-outs and data. Jaar's line functions differently: artistically referencing the rise and fall of sounds but bearing no actual relationship to the syllables that the artist asks us to identify in the photographs, his controlled scribbles can be better interpreted through the smile and frown next to which they appear. Splitting the first panel of *What's going on with Chilean art?* into two horizontal registers, the bottom contains *Studies on Happiness* in miniature — that is, the tensions of photographic capture and spoken speech, and more importantly, the potential for a fluidity beyond the stereotypical poles of 'happy' and 'sad' as cued in the overlapping marks apparent across the space of Jaar's grid. Like the unknowable fullness of the mind represented in the EEG, Jaar's rendering of sound escapes the confines of language actually spoken, and in doing so makes space for the variation, or even just plain messiness, of unspoken thought and feeling.

Purgatory ends not with Paradise, but with an unmarked page of EEG data. In a book attentive to visual juxtaposition, and as the only pages printed in colour, Zurita concludes his poem with a purposeful textual absence and an electrical field. Legible, perhaps, as sky — the regular lines of yellow recast as sunlight against a rush of atmospheric blue — brain waves potentially hold a space of communion, a knowability beyond the blunt instrument of language. The open linearity of the EEG evokes a similar space to that offered by Jaar, though one housed within the electrical circuitry of the television in *An Open Work — A Non-Stop Record*. Neither imagined landscape nor telepathic paradise, Jaar's screen in that work offered a space of possibility, much like the text-free page. The 525 lines of data that make up an analogue televisual signal run horizontally, their flickers and refreshes suitably cued by the wavering blue that cuts across Zurita's poem. Deployed as a site of public appearance and speech — at times even of witness and

testimony — for Jaar television seeks neither to measure nor to diagnose, but rather simply receives, as a place of openness rather than closure.

If the interiority of Zurita's narrator disperses, in the end, into the jagged representation of electrical current, his person finds form before Jaar's camera, where, as part of *An Open Work — A Non-Stop Record,* the poet and artist appeared — his white collared shirt nearly merging with the white background in the video — and, in answer to Jaar's questions, recited a short poem (fig.25). Zurita has since recalled an atmosphere of intrigue and curiosity among those waiting to sit before Jaar's camera and those simply there to observe the proceedings, triggered by its innocent-seeming questions. According to Zurita, 'at the time in Chile, the question "Are you happy?" was highly subversive, it was a bomb installed in the heart of the system and of the people'.[202] Faced with the question, he makes his time in front of the camera brief; he quicky dispenses with Jaar's demographic questions, naming his occupation as 'writer' before answering the broader queries 'Are you happy?' and 'What does happiness mean to you?' with the following:

> *Entonces, aplastando la mejilla quemada*
> *contra los ásperos granos de este suelo pedregoso*
> *— como un buen sudamericano —*
> *alzaré por un minuto más mi cara hacia el cielo*
> *llorando*
> *porque yo que creí en la felicidad*
> *había vuelto a ver de nuevo las irredargüibles estrellas*
>
> *[Then, ground my burned cheek*
> *against this rough gravel stone earth*
> *— like a good South American —*
> *I'll lift up my face one minute more toward the sky*
> *weeping*
> *because I who believed in happiness*
> *had turned to see again the irrefutable stars]*[203]

In the recorded video, during the 25 seconds it takes Zurita to voice these lines, his eyes meet our gaze briefly, as he raises them with the word 'llorando' (weeping); he then shifts them across the field of the camera until he finishes his next line, ending on 'felicidad' (happiness). The poem, with its starting reference to Zurita's own burned cheek, as in *Purgatory*, positions him low, prostrate — either dominated or humble — and overcome with emotion at his own belief in a possible happiness, as evinced in the glimmering of the stars. If, in *Purgatory*, Raúl/Raquel's cheek is the 'shattered' and starry (*estrellado*) sky, in the poem read before the camera, the stars come from above as his cheek presses the earth. Yet in Zurita's emotional response — 'I'll lift my face … weeping' — the narrator's composure is shattered, overcome by the celestial body above, which confirms, perhaps, a space of wonder and happiness both within and without.

Zurita's poetic response directly engages with Jaar's questions, though his verses have since had a life that exceeds their voicing and capture in 1981, and the recording documents the first time he read them in public.[204] A slightly altered version of the same poem appears as the penultimate poem in *Anteparadise*, a work that the poet 'conceived as a total structure, a trajectory beginning with the experience of everything precarious and painful in our lives and concluding with a glimmer of happiness'.[205] Here, the poem functions to mark a hopefulness, a 'splendor in the wind'[206] and an acknowledgement, as the last lines of the book would have it:

HEY LISTEN IF YOU'RE NOT FROM A POOR BARRIO IN SANTIAGO IT'LL / BE HARD FOR YOU TO UNDERSTAND ME YOU WOULDN'T KNOW ANYTHING / ABOUT THE LIFE WE LEAD LOOK IT'S HOPELESS IT'S INSANITY IT'S / FALLING TO PIECES FOR JUST A MINUTE OF HAPPINESS[207]

Zurita defines the entirety of artistic production against happiness, beginning his introduction to *Anteparadise* with a flat assertion: 'I won't dwell on the subject, but the fact is, we make literature, art, music only because we're not happy. Thus all the books that have been written, the great works of art. We have not been happy.'[208] And if, as the poet would have it, all creative

production comes from an unsettled feeling, and if whatever beauty humanity has created is fuelled by sadness, dread, disappointment, pain, indifference and the many other feelings that fall outside happiness, that creative output might still hold out for something called happiness, even if it is just an imagining otherwise. In collecting his own work in the personal anthology *Tu vida rompiéndose* (*Your Life, Splitting Apart*, 2015), Zurita seems to argue the same by placing the poem he read at Jaar's installation at the end of his collection, as his 'last poem' — effectively offering these lines as the glimmer, or perhaps mirage, of possible happiness that motivates his entire poetic corpus.

In reflecting on his participation in Jaar's work, Zurita has described his unique receptivity to the depth of the questioning and its implications:

> Studies on Happiness *and its central articulation, the question 'Are you happy?', had an enormous impact on me, perhaps because I was prepared to understand it. The question immediately brought a poem to mind, which, in a certain part, said something like 'because I believed in happiness...' [...] I realised then that happiness was a belief of mine as well as a battle, which is none other than the battle waged by millions and millions of human beings across the face of the earth to become human beings and to continue in life as such.*[209]

I do not know whether Zurita's experience of reciting his poem before the camera, or of watching others respond to Jaar's questions in whatever way they chose, helped focus a latent aspect of *Anteparadise*, or whether his various calls to happiness were already fully formed within the work. Yet, in describing Jaar's work in general, and through language that could perhaps be applied to his own poetics, Zurita observes that 'the theme of happiness and its questions course through Alfredo Jaar's work in the deepest and most radical sense'.[210] And yet, as true as Zurita's statement may be, *Studies on Happiness* is not a 'happy' work. Jaar conceptualised it in a moment of personal isolation and creative ambition, in a time and place where options for expression were limited and fear was real. His asking confronted these limits, each in turn.

Happiness. Are you happy? What does happiness mean to you? Happy.
Unhappy. When you repeat something too many times, when you look at it
for long enough, sometimes it disintegrates and stops sounding like the word
you know, or the letters stop fitting together somehow. Psychologists call
this semantic satiation. In some religions, it's called a mantra. Modernists
called it defamiliarisation. Conceptualists called it seriality. In Jaar's case,
in Santiago between 1979 and 1981, I call it an opening.

NOTES

1 Henri Bergson, *Laughter: An Essay on the Meaning of the Comic* (1900, trans. Cloudesley Brereton and Fred Rothwell), Mansfield Center, CT: Martino Publishing, 2014, p.18.

2 Alejandro Zambra, *Ways of Going Home* (2011, trans. Megan McDowell), New York: Farrar, Straus and Giroux, 2013, pp.40–41.

3 Nona Fernández, *Space Invaders* (2013, trans. Natasha Wimmer), Minneapolis: Graywolf Press, 2019, p.31.

4 Alfredo Jaar, untitled text, in Adriana Valdés, *Studies on Happiness, 1979–1981*, Barcelona: Actar, 1999, n.p. This volume was published in both English and Spanish editions. I have used the English throughout, though I have consulted the Spanish version for the original titles. The translators credited in the English edition are Vincent Martin, Anne Morgan and Adriana Valdés.

5 A. Valdés et al., 'Alfredo Jaar, Conversations in Chile, 2005', in A. Valdés (ed.), *JAAR SCL 2006*, Barcelona: Actar, 2006, p.69.

6 *Ibid.*

7 Sol Peláez makes a related point in relation to the reception of the work at the time of its production in her analysis of *Studies on Happiness*, writing that '*Studies*, from today's vantage point, makes an impact because it *barely* did so under the dictatorship'. S. Peláez, '*Estudios sobre la felicidad:* Alfredo Jaar y el estremecimiento del goce', *AISTHESIS*, no.65, 2019, p.39. Emphasis in original. Author's translation.

8 Enrique Lihn, 'Fragments' (1973, trans. Jonathan Cohen), in *The Dark Room and Other Poems*, New York: New Directions, 1978, p.133.

9 Steve J. Stern, *Battling for Hearts and Minds: Memory Struggles in Pinochet's Chile, 1973–1988*, Durham, NC: Duke University Press, 2006, p.231.

10 See Patricia C. Phillips and Alfredo Jaar, 'The Aesthetics of Witnessing: A Conversation with Alfredo Jaar', *Art Journal*, vol.64, no.3, Fall 2005, pp.6–27.

11 *Ibid.*, p.14.

12 The rough divisions of the various phases of the project vary slightly depending on the source. The original divisions used by the artist in 1981, as documented in the self-published *Obra Abierta y de Registro Continuo*, do not include the proto-phase of research that is included in the chronology published in 1999 in A. Valdés, *Studies on Happiness*, *op. cit.* Jaar's current summary of the project no longer includes this research process; it essentially reverts to the original division defined in 1981. In what follows, I have used the Spanish titles as they appear in the project's first iteration. The image captions, instead, conform to Jaar's preferred current titling in English.

13 I use the language of 'scenario' in reference to the work of Diana Taylor, who asserts that 'the scenario makes visible, yet again, what is already there: the ghosts, the images, the stereotypes', just as it 'demands that we also pay attention to milieux and corporeal behaviors such as gestures, attitudes, and tones not reducible to language'. See D. Taylor, *The Archive and the Repertoire: Performing Cultural Memory in the Americas*, Durham, NC: Duke University Press, 2003, p.28.

14 Luisa Ulibarri, 'Alfredo Jaar: ¿Es usted feliz?', *Clan*, March 1982, p.85. Author's translation. Jaar described specific locations in Santiago in a telephone interview with the author on 26 July 2021, when he added that he chose the neighbourhoods with an attention to class dynamics in the city.

15 The dates of Jaar's first set of questions are printed on the poster itself: 5, 7, 19 and 23 June 1980. However, photographs were taken on only one occasion, thus all images feature Jaar in the same clothing, and the newspapers affixed to the kiosk adjacent to his performance display the same headlines. Documentation can be found in A. Valdés, *Studies on Happiness*, *op. cit.*, n.p.; and the discussion of friends in an interview with Luis Pérez-Oramas, in *El Poder de una Idea: Un Espacio de Tiempo con Alfredo Jaar y Luis Pérez-Oramas*, ed. Yanina Valdivieso, New York: Fundación Cisneros, 2021, p.32. In a conversation with the author in New York on 21 October 2022, Jaar confirmed that there was only a single day of shooting photographs.

16 Jaar describes his strategy of deploying the more general question as a type of protection against possible police suspicion in the interview with L. Pérez-Oramas, in *El Poder de una Idea*, *op. cit.*, pp.32–33.

17 To my knowledge, no documentary photographs exist of this second series of questions. Jaar posed questions on 1, 5 and 6 August, and again on 2 September 1980. Documentation in A. Valdés, *Studies on Happiness*, *op. cit.*, n.p.

18 This inversion is noted in S. Peláez, '*Estudios sobre la felicidad*', *op. cit.*, p.48.

19 In an early article on the project, these two sets of questions are described as separate events, and the author writes that Jaar got one hundred people to answer the question 'Are you happy?' See Ana Foxley, 'Felicidad en la Mira', *Hoy*, 9–12 January 1982, p.42.

20 In this way, Jaar distinguished between phase one and two in an early interview related to the project, conducted by Gregorio Goldberg for the men's magazine *Bravo*, edited by Mario Fonseca. As Jaar explained to *Bravo*'s readers: 'I walked around Santiago and asked people three questions.' Notably, he did not distinguish between the questions asked as he later would. See G. Goldberg, 'Alfredo Jaar: Las siete estaciones de una "obra abierta"', *Bravo*, no.56, February 1982, p.6. Author's translation.

21 Gabriel García Márquez, *Clandestine in Chile: The Adventures of Miguel Littín* (1986, trans. Asa Zatz), New York: New York Review Books, 2010, p.17. While secretly in the country with a small crew, Littín filmed a documentary about life under Pinochet, *Acta General de Chile* (1986).

22 *Ibid.* The space of marginality as a site of speech finds a related form in the figure of Pingüino, a panhandler in Enrique Lihn's 1983 collection of poems, *Paseo Ahumada*, which was originally produced as a newsprint broadside. See E. Lihn, *Poesía reunida*, Santiago: Ediciones Universidad Diego Portales, 2018.

23 In Jaar's original chronology of the project from 1981, as well as in the 1999 version, the individual interviews, known as *Entrevistas Personales* (*Interviews*), constitute phase three, with the panels that comprise *Portraits of Happy and Unhappy People* categorised as phase four. Jaar currently groups these together as phase three.

24 A. Foxley, 'Felicidad en la Mira', *op. cit.*, p.42.

25 The phrase 'pictorial statistics' is Francis Galton's, which I take from Allan Sekula's classic text on early photography and social control, 'The Body and the Archive', *October*, vol.39, Winter 1986, pp.3–64. On 'pictorial statistics', see pp.47–48.

26 A. Jaar, in G. Goldberg, 'Alfredo Jaar: Las siete estaciones de una "obra abierta"', *op. cit.*, p.6. On the aesthetics of administration, see Benjamin H.D. Buchloh, 'Conceptual Art, 1962–1969: From the Aesthetic of Administration to the Critique of Institutions', *October*, vol.55, Winter 1990, pp.105–43.

27 Jaar described the number of completed *Portraits of Happy and Unhappy People* as well as his relationship to each of the featured individuals in a phone conversation with the author on 5 July 2022.

28 It is worth noting that Mirna appears as case number 58 in *Portraits of Happy and Unhappy People*, while in the photo documentation of *Situations of Confrontation* she appears as case number 67. In discussing this discrepancy, Jaar has noted, 'It's a mistake.' The numbers in both instances seem to have been chosen to provide a more authentic appearance of numerical depth and breadth, in the process conferring an archival authenticity to the work. Information provided by Jaar in a phone conversation with the author on 5 July 2022.

29 'Yo no *represento* nada, no trabajo con sistemas tradicionales de *representación*: aquí los *presento*.' A. Jaar, in G. Goldberg, 'Alfredo Jaar: Las siete estaciones de una "obra abierta"', *op. cit.*, p.7. Emphasis in the original.

30 *Ibid.*

31 A. Jaar, quoted in A. Foxley, 'Felicidad en la Mira', *op. cit.*, p.42. It is worth noting that Jaar still describes the magic of this experience in quite similar terms. See his much more recent discussion of the same event in conversation with Luis Pérez-Oramas, in *El Poder de una Idea, op. cit.*, pp.38–41.

32 Luis Pérez-Oramas follows this line of thought as well, exploring the idea of the art giving rise to a community through its actions, while Jaar discusses the architectural underpinnings of the programme for *Studies*. See *ibid.*, pp.38–41 and 46–47. As Jaar has described in relation to his practice overall: 'Because I am an architect, and I want to communicate, in every project I give myself a program. I say to myself: this is what I want to do, this is what I want to say, this is what I want to achieve, and this is what I want to communicate with my audience.' See '"I need to understand the world before acting in the world": Pirkko Siitari in Conversation with Alfredo Jaar', in Patrick Nyberg and Jari-Pekka Vanhala (ed.), *Tonight No Poetry Will Serve*, Helsinki: Museum of Contemporary Art Kiasma, 2014, p.73.

33 In both the 1981 and 1999 chronologies, no distinction is made between the installation and the recorded video footage of *An Open Work*. Jaar now divides these works between the physical installation and the resulting documentation. The English title refers to this later demarcation.

34 Luis Camnitzer, *Conceptualism in Latin America: Didactics of Liberation,* Austin: University of Texas Press, 2007, p.90. A similar type of condensation occurs in Milan Ivelic and Gaspar Galaz's *Chile, arte actual* (Valparaíso: Universidad Católica de Valparaíso, 1988), though their description of different phases of *Studies on Happiness* is limited to a caption of various photographs. The caption does, however, suggest that the *Public Interventions* did take place on the streets of Santiago (p.244). For a more recent analysis that asserts the presence of these works in public space, see S. Peláez, '*Estudios sobre la felicidad*', *op. cit.*, pp.38 and 55. For another general summary that has images of the *Public Interventions* and presents them as having happened, see Peter Osborne, *Conceptual Art,* New York: Phaidon, 2002, p.147.

35 See Jaar's official chronology of the project, as outlined in A. Valdés, *Studies on Happiness, op. cit.*, n.p.

36 Graffiti and other more ephemeral modes of public address — at least ones that would not require the rental of advertising space, with its attendant paper trail — were essential to voicing dissent at this time and over the coming years. See Camilo D. Trumper, *Ephemeral Histories: Public Art, Politics, and the Struggle for the Streets in Chile,* Berkeley: University of California Press, 2016, in particular pp.162–93. Trumper's larger argument asserts a continuity rather than a radical break — as Nelly Richard would have it — from the days of the Unidad Popular through to the 1970s and early 1980s, at least insofar as street actions and related art and protest. For a summary description of the *No + action,* briefly mentioned in Trumper (p.3) without explicit reference to CADA, see Robert Neustadt, *CADA día: la creación de un arte social* (Santiago: Cuarto Propio, 2001), where he describes the clandestine spraying of 'No +' all over the city by the artists and their friends under cover of darkness, and how, upon discovery, the graffiti was augmented with particular words like 'No + Pinochet' or 'No + Tortura' by unknown participants (pp.33–34). Jaar described his process of gathering pricing information for advertising spaces in a Zoom conversation with the author on 30 January 2023.

37 Jaar provided this information directly during an interview with the author in New York City on 14 March 2019. Mario Fonseca, a friend of Jaar's at the time, suggested that perhaps one of the smallest and most doable versions of the billboards — a tiny placard over a trash can — may have been constructed. Email exchange between M. Fonseca and the author, October 2019.

38 Ana María Risco, *La deriva líquida del ojo,* Viña del Mar, Chile: Mundana Ediciones, 2017, pp.36–37. Author's translation.

39 L. Ulibarri, 'Alfredo Jaar: ¿Es usted feliz?', *op. cit.*, p.85.

40 A. Foxley, 'Felicidad en la Mira', *op. cit.*, p.42.

41 A. Jaar, in G. Goldberg, 'Alfredo Jaar: Las siete estaciones de una "obra abierta"', *op. cit.*, pp.7–8.

42 In the early stages of my own research, before confirming the status of these works with Jaar, I had a conversation with my father about his time in Santiago and asked him whether he had seen or heard about these billboards. He was firm in his conviction that, given his understanding of the space available for dissenting speech, which he acquired in his work and political reporting through the US Embassy, such an action would not have happened in 1981.

43 Jaar confirmed, in a telephone interview with the author on 25 November 2019, that he did not strategically provide *Public Interventions* images to the media as a way to suggest their physical presence in and around Santiago. 'I wish it were so', he said.

44 Roberto Jacoby, Eduardo Costa and Raúl Escari, 'A Media Art (Manifesto)' (1966, trans. Trilce Navarrete), in Alexander Alberro and Blake Stimson (ed.), *Conceptual Art: A Critical Anthology,* Cambridge, MA: MIT Press, 1999, pp.2–3.

45 R. Jacoby, 'Against the Happening' (1967, trans. Natalia Sucre), *October,* vol.153, Summer 2015, p.20. See also A. Alberro, 'Media, Art and Politics in the Work of Roberto Jacoby', in *ibid.*, pp.3–13; and Karen Benezra, *Dematerialization: Art and Design in Latin America,* Berkeley: University of California Press, 2020, in particular her analysis of the philosopher and artist Oscar Masotta and the Argentine art world, pp.27–58.

46 See Jacoby's quotation and discussion of Barthes in R. Jacoby, 'Against the Happening', *op. cit.*, pp.21–22. See also, Roland Barthes, *Mythologies* (1957, trans. Annette Lavers), New York: Hill and Wang, 1972.

47 Jaar described this situation with a laugh in conversation with the author in New York on 14 March 2019.

48 For a broader discussion of work presented alongside Jaar's at the Séptimo Concurso Colocadora Nacional de Valores, in particular the video installation of Diamela Eltit and Lotty Rosenfeld's *Traspaso Cordillerano (Andean Crossing)*, see M. Ivelic and G. Galaz, *Chile, arte actual, op. cit.*, pp.241–43.

49 L. Ulibarri, 'Alfredo Jaar: ¿Es usted feliz?', *op. cit.*, p.85.

50 A. Foxley, 'Felicidad en la Mira', *op. cit.*, p.41.

51 Valdés described this initial meeting following a lecture she gave at the Universidad de Chile on the Chilean writer Juan Emar (née Álvaro Yañez Bianchi) as follows: 'At the end of the lecture, a young man approached me. We had not met before. He said his name was Alfredo Jaar; he was an architect, he was in the visual arts. He wanted to show me something. I was apprehensive. My field was really literature, though I had also written on art. I dreaded having to repeat the cautious remarks I had so often made to young people. "I distrust spontaneity, which stems directly from stereotypes and habits." This phrase by Barthes summarizes the fear I felt — which was entirely generic and makes me smile in retrospect. (I had no way of knowing who had approached me.) The following day — "it will not take up more than an hour of your time," he had said, firmly and professionally — I was introduced to *An Open Work — A Non-Stop Record*. It exceeded my terms of reference, and this excited me. It forced me out of my own cliches and made it impossible for me to repeat myself. It created risk. It had no one's blessing. It attracted me strangely.' A. Valdés, *Studies on Happiness, op. cit.*, n.p.

52 A. Valdés, 'An Open Work — A Non-Stop Record' (1981), in *ibid.*, n.p. Unpaginated in original Spanish typescript as well.

53 *Ibid.*, n.p.

54 *Mensaje* had a rough circulation of 13,000. See S.J. Stern, *Battling for Hearts and Minds, op. cit.*, pp.432–33, n.41.

55 A. Valdés, 'Escritura y Silenciamiento', *Mensaje*, no.276, January/February 1979, p.41.

56 A. Jaar, in G. Goldberg, 'Alfredo Jaar: Las siete estaciones de una "obra abierta"', *op. cit.*, p.8.

57 A. Zambra, *Ways of Going Home, op. cit.*, pp.10–11. For historical accounting of media control, see S.J. Stern, *Battling for Hearts and Minds, op. cit.*, pp.60–62.

58 As Jaar would recall: 'At that time I was citing Haacke. Ironically, I found out later that Haacke was citing David Lamelas, an Argentine, who still hasn't been given his due in the art scene. People didn't see any further than Haacke.' Quoted in A. Valdés et al., 'Alfredo Jaar, Conversations in Chile, 2005', *op. cit.*, p.71. It was through his exposure to Haacke that Jaar came to know of David Lamelas's *Office of Information about the Vietnam War at Three Levels: The Visual Image, Text and Audio* (1968).

59 Luz María Williamson asserts that Jaar's phrasing of 'Are you happy?' is a 'literal citation' of the Rouch and Morin film. See L.M. Williamson, *Memoria y Amnesia: Sobre la historia reciente del arte en Chile, 1976–2006*, Barcelona: Ediciones Polígrafia, 2017, p.239, n.614. Jaar stated that he did not know of the film at the time in a telephone interview with the author on 25 November 2019.

60 A. Jaar, interview with the author, New York, 14 March 2019.

61 The term *escena de avanzada* is associated with Nelly Richard's *Margins and Institutions: Art in Chile since 1973* (Melbourne: Art & Text, 1986). Richard's earlier series of remarks in *Una mirada sobre el arte en Chile*, her self-published text of 1981 wherein the term *de avanzada* is first introduced as part of a fragmented and self-consciously partial survey, offers a more fluid accounting, which would have been available to Jaar at the time. While *escena de avanzada* is the name by which the Chilean avant-garde of this time is now known, it is generally a retrospective naming that I have consciously avoided in an attempt to stay as closely rooted in the moment of Jaar's work as possible.

62 Adriana Valdés postscript to the republication in 1999 of her 'An Open Work — A Non-Stop Record' notes that she was a fish who did not account for the water. 'The text can explode in three different directions. One direction is the national political circumstances in which the work was viewed. The second is what was happening in the visual arts in Chile, and how this excluded and failed to understand Jaar's work. And the third is this early work reviewed in the light of Jaar's subsequent development as an artist, which sheds light on some elements of the work and makes it possible to read it differently, or in ways that are only intuitively suggested by the text.' A. Valdés, 'Post Scriptum', in *Studies on Happiness, op. cit.*, n.p. This text attends, in its way, to some of these contexts.

63 A. Zambra, 'My Documents', in *My Documents* (2014, trans. Megan McDowell), London: Fitzcarraldo Editions, 2015, e-book.

64 On the state of political repression circa 1980, see S.J. Stern, *Battling for Hearts and Minds, op. cit.,* p.222. For a discussion of the disappeared and consideration of reasonable estimates, see S.J. Stern, *Remembering Pinochet's Chile: On the Eve of London 1998*, Durham, NC: Duke University Press, 2004, pp.158–61, n.3. For a chilling blow-by-blow of the apparatus of torture and related US government communications, see Peter Kornbluh (ed.), *The Pinochet File: A Declassified Dossier on Atrocity and Accountability*, New York: The New Press, 2003, especially pp.161–207.

65 See Hugo Fruhling, 'Resistance to Fear in Chile: The Experience of the Vicaría de la Solidaridad', in Juan E. Corradi, Patricia Weiss Fagen and Manuel Antonio Garretón (ed.), *Fear at the Edge: State Terror and Resistance in Latin America*, Berkeley: University of California Press, 1992, pp.121–41.

66 S.J. Stern, *Battling for Hearts and Minds, op. cit.,* p.154. For a thorough discussion of *¿Dónde están?*, see also Ángeles Donoso Macaya, *The Insubordination of Photography: Documentary Practices Under Chile's Dictatorship*, Gainesville: University of Florida Press, 2020, pp.35–80. I draw on aspects of this analysis in what follows.

67 Vikki Bell, 'Documenting Dictatorship: Writing and Resistance in Chile's Vicaría de la Solidaridad', *Theory, Culture & Society*, vol.38, no.1, 2021, p.60.

68 For a detailed discussion of the materiality of the Vicariate's ledger, see *ibid.*, pp.60–67.

69 Á. Donoso Macaya, *The Insubordination of Photography, op. cit.*, p.51.

70 *Ibid.*, p.61.

71 S.J. Stern, *Battling for Hearts and Minds, op. cit.*, pp.146–54.

72 Michael Taussig, 'Terror as Usual: Walter Benjamin's Theory of History as State of Siege', in *The Nervous System*, New York: Routledge, 1992, p.27. For an analysis of different historical (and intergenerational) uses of this type of imagery in the context of Argentina's Dirty War through to the early 2000s, see D. Taylor, '"You Are Here": H.I.J.O.S and the DNA of Performance', in *The Archive and the Repertoire, op. cit.*, p.161–89.

73 N. Fernández, *The Twilight Zone* (2016, trans. Natasha Wimmer), Minneapolis: Graywolf Press, 2021, p.71.

74 Á. Donoso Macaya, *The Insubordination of Photography, op. cit.*, pp.36–37. On the history of the TAV, see Paulina Varas, *Luz Donoso: El arte y la acción en el presente*, Santiago: Ocho Libros, 2018, pp.108–23; and Felipe Baeza and José Parra, 'Taller de Artes Visuales (TAV): Producción, difusion, y reflexión sobre el grabado en Chile durante la Dictadura', in F. Baeza, J. Parra, Amelia Cross and Francisco Godoy Vega (ed.), *Ensayos sobre artes visuales: Prácticas y discursos de los años 70 y 80 en Chile. Vol 2*, Santiago: LOM, 2012, pp.17–62.

75 See P. Varas, *Luz Donoso, op. cit.*, pp.196–201; and Á. Donoso Macaya, *The Insubordination of Photography, op. cit.*, pp.63–64. It is worth noting that the dating of the *Huincha sin fin* seems unclear. Certain sources, at least in relation to a specific photo of the *Huincha* that hung in Donoso's home, date the work to 1978 (see Cecilia Fajardo-Hill and Andrea Giunta (ed.), *Radical Women in Latin American Art: 1960–1985*, Los Angeles: Hammer Museum and DelMonico/Prestel, 2017, p.93) and others to 1982 (see L.M. Williamson, *Memoria y Amnesia, op. cit.*, p.61). Paulina Varas dates the first iteration to 1979, based on Hernán Parada's recollection. The photograph of the *Huincha* unfurled on a stairwell typically carries no date. The *Huincha* reproduced in Donoso's home seems to include a copy of Donoso and Parada's *Acción de Apoyo* of a photo on a wall, which is typically dated to 1982. My argument does not hinge on temporal priorities or firsts, but I would be inclined to date the *Huincha sin fin* to 1979, following Varas, but the particular photograph as showing a 1982 iteration.

76 Hernán Parada, in 'Testimonio de una amistad latente: Una conversación con Hernán Parada', in P. Varas, *Una Acción hecha por otro es una obra de la Luz Donoso*, Santiago: Centro de Arte Contemporáneo Municipalidad de Las Condes, 2011, p.10. Author's translation.

77 Luz Donoso, Patricia Saavedra and H. Parada, 'Acciones de Apoyo', in Colectivo de Acciones de Arte (CADA), *Ruptura*, Santiago: Ediciones CADA, 1982, p.4.

78 The clearest and best illustrated source on these works is P. Varas, *Luz Donoso, op. cit.*, pp.178–87.

79 *Ibid.*, pp.183–84; and Á. Donoso Macaya, *The Insubordination of Photography, op. cit.*, pp.65–66. On Lila Valdenegro, see https://memoriaviva.com/nuevaweb/detenidos-desaparecidos/

desaparecidos-v/valdenegro-carrasco-lila-ludovina/ (accessed on 8 July 2022). The catalogue entry in *Copiar el edén: Arte reciente en Chile / Copying Eden: Recent Art in Chile* (Gerardo Mosquera (ed.), Santiago: Puro Chile, 2006, p.268) states that the *Support Action: Intervention into a Commercial System* lasted twelve hours, which seems an exaggeration.

80 Patricia Saavedra remembers this in her 1982 conversation with Donoso and Juan Downey as transcribed in P. Varas, *Luz Donoso, op. cit.*, p.178. ('La gente de los negocios preguntaban: "¿Estos son delincuentes?"')

81 L. Donozo, P. Saavedra and H. Parada, 'Acciones de Apoyo', *op. cit.*, p.4. Translated by Á. Donoso Macaya in *The Insubordination of Photography, op. cit.*, p.65. Varas has noted that this was the first public use of the general name 'Support Actions', see P. Varas, *Luz Donoso, op. cit.*, p.178.

82 The varied actions undertaken by CADA can be equally approached through this theoretical lens. Indeed, in a retrospective accounting from 1998, it is Fernando Balcells's assertion that 'the concept of an "open work" came to us like a ring to a finger', though in 1979 the collective would make more concrete reference to Joseph Beuys's concept of 'social sculpture' in framing the wider action of *Para no morir de hambre en el arte* (*Not to Die of Hunger in Art*). For Balcells's statement, see R. Neustadt, *CADA día, op. cit.*, p.73; and for CADA's assertion of a social sculpture, see Colectivo Acciones de Arte, 'para no morir de hambre en el arte', *La Bicicleta 5*, November –December 1979, pp.22 and 24, n.2. The relationship between CADA's conception of an 'open work' and the Beuysian precedent of social sculpture, with reference to the above statements, is discussed in Jason Dubs, *Making a Scene: The Colectivo Acciones de Arte, the Chilean Neo-Avant-Garde, and the Politics of Visibility, 1975–1989*, PhD dissertation, New York: New York University, 2013, pp.83–86.

83 L. Donozo, P. Saavedra and H. Parada, 'Acciones de Apoyo', *op. cit.*, p.4.

84 For a fascinatingly detailed discussion of this project and its interrelationship with the photographic project undertaken in *¿Dónde están?*, see Á. Donoso Macaya, *The Insubordination of Photography, op. cit.*, pp.69–77.

85 A timeline of the project with some visual documentation can be found at https://

hernanparada.cl/cronologia/ (accessed on 8 July 2022). For a description of this work and Parada's collaboration with Donoso, see P. Varas, *Luz Donoso, op. cit.*, pp.124–37. According to the latter account, Parada wrote an academic thesis around this work, explicitly linking his own practice to Umberto Eco's theorisation of the 'open work' and to Happenings (pp.127–32). Varas's text also illustrates a related work where Parada stood, on his 27th birthday in 1980, on the Calle Alameda with a sign reading 'Art Proposition: Celebrate 10,000 days of the existence of anyone'. Jaar can be seen in the photograph looking up at Parada's sign along with Nelly Richard and others (p.133). Parada's thesis describes a variety of differences between his *obrabierta* and the art and theorisations of Allan Kaprow, Marcel Duchamp and Eco. Ultimately Parada distinguishes his work from these earlier precedents via their status as bounded, if indeterminate, artworks rather than open interventions into the world. In marking the difference between Eco's 'open work' and his own *obrabierta*, Parada is clear in writing that '[Eco's] Open work formula is not applicable to the system of *obrabierta*, because the latter, in itself, is not conceived as an artistic work'. H. Parada, *Obrabierta: Memoria para optar el grado académico de Licenciado en Artes Plásticas con mención en Grabado*, Santiago: Facultad de Bellas Artes, Universidad de Chile, 1980, pp.29–30. Author's translation. My thanks to Hernán Parada for sharing a copy of this text with me.

86 Umberto Eco, 'The Poetics of the Open Work' (1962, trans. Anna Cancogni), in *The Open Work*, Cambridge, MA: Harvard University Press, 1989, p.19.

87 Adriana Valdés, in an email correspondence with the author on 25 November 2022, confirmed the importance of *The Open Work* and of Eco more generally to the intellectual community in Chile at the time. As a professor, Valdés noted that Eco's texts were part of a bibliography she would recommend to interested students.

88 It is beyond the scope of this text to engage both Richard's categorisation and the debates it has generated in all their complexity. On this history, see Carla Macchiavello, 'Vanguardia de exportación: la originalidad de la "Escena de Avanzada" y otros mitos chilenos', in Fernanda Carvajal, María José Delpiano and C. Macchiavello (ed.), *Ensayos sobre artes visuales: Prácticas y discursos de los*

años 70 y 80 en Chile. Vol. 1, Santiago: LOM, 2011, pp.87–117. See also, for example, F. Godoy Vega (ed.), 'Cuerpos que machan, cuerpos correcionales: Sedimentación y fractura en la escritura de/sobre arte en Chile en 1980', in F. Baeza, J. Parra, A. Cross and F. Godoy Vega, *Ensayos sobre artes visuales: Prácticas y discursos de los años 70 y 80 en Chile. Vol 2, op. cit.*, pp.101–44; A. Valdés, 'A los pies de la letra: arte y escritura in Chile', in *Memorias visuales: Arte contemporánio en Chile*, Santiago: Metales Pesados, 2006, pp.277–303; and Andrea Giunta, 'Escritura en grisalla', in Daniella Gonzáles Maldini (ed.), *El revés de la trama: escritura sobre arte contemporanio en Chile*, Santiago: Universidad Diego Portales, 2010, pp.11–23. For a particularly strident critique of Richard's position, see Willy Thayer, 'Crítica, nihilismo e interrupción: la *Avanzada* después de *Márgenes e Instituciones*', in *El fragmento repetito: escritos en estado de excepción*, Santiago: Metales Pesados, 2006, pp.47–94.

89 Jaar discussed his attendance in the seminar and his initial engagement with Nelly Richard in a telephone interview with the author on 25 November 2019. Jaar had been taking a course in European cinema at the Instituto prior to Richard's seminar.

90 Luz Donoso recorded this seminar and details of its content with notes can be found in P. Varas, *Luz Donoso, op. cit.*, pp.96–100. A few artists and professors responded to Richard's seminar in the form of answers to a questionnaire, which was published as 'Situación Seminario Arte Actual 1979' in the arts magazine *La Bicicleta*, August/September 1979, pp.44–46. A brief statement drawn from Richard's introductory remarks in the seminar was published in *cal 3* (1979) as part of 'Dossier: Critica de arte en Chile', p.8.

91 Nelly Richard, *Una mirada sobre el arte en Chile/Octubre de 1981*, Santiago: self-published, 1981, p.3. Author's translation.

92 *Ibid.*, pp.15–17 (pages are numbered with odd numbers; these are successive pages). Though Richard names Jaar parenthetically, her text does not delve more deeply into his practice.

93 *Ibid.*, p.15.

94 While in what follows I try to set aside the factional divisions of the various players in the Santiago art world, the scene was split into three general groups: the artists Carlos Leppe and Carlos Altamirano, who were championed by Nelly Richard; the grouping of Eugenio Dittborn with Catalina Parra and Ronald Kay, and their publishing endeavours under the name V.I.S.U.A.L.; and the artists and writers associated with the Colectivo de Acciónes de Arte, known as CADA (Fernando Balcells, Juan Castillo, Diamela Eltit, Lotty Rosenfeld and Raúl Zurita).

95 For a brief discussion, see Liz Munsell, *Embodied Absence: Chilean Art of the 1970s Now* (exh. pamphlet), Cambridge, MA: Carpenter Center, Harvard University, 2017; as well as Carlos Leppe's website, http://carlosleppe.cl/1980-las-cantatrices/ (accessed on 8 December 2022).

96 N. Richard, *Cuerpo Correccional*, Santiago: Francisco Zegers, 1980, p.71. Author's translation.

97 *Ibid.*, p.11.

98 'Make-up renders conventional your non-animal face, stipulated by cosmetic conventions or instituted by a facial stereotype.' *Ibid.*, p.33.

99 *Ibid.*, p.41.

100 Eugenio Dittborn, 'Un texto para *final de pista*', in *Final de Pista*, Santiago: Galería Epoca, 1977, p.18. Author's translation.

101 *Ibid.*

102 *Ibid.*, p.11. 'The painter owes his work to the body of the individual deported in a photographic state to the collective space of the magazine, in consecration of their perpetual helplessness.' This would be rephrased and included as part of 'Caja de herramientas', a text of Dittborn's included in Ronald Kay, *Del espacio de acá: Señales para una mirada americana* (1980), Santiago: Metales Pesados, 2005, p.68.

103 Like Richard, Kay was an essential figure in the composition of the Chilean avant-garde. With his then-wife, the artist Catalina Parra, daughter to the poet Nicanor Parra and niece to Violeta Parra, and Enrique Lihn and Cristian Huneeus, Kay worked on the production of *Manuscritos* (1975), which stands as a foundational document for post-1973 Chilean art. See *Manuscritos*, Santiago: Departamento de Estudios Humanisticos, Universidad de Chile, 1975. As a writer and professor in the Department of Humanistic Studies (DEH) at the Universidad de Chile, Kay was instrumental in introducing the writings of Walter Benjamin, Martin Heidegger and Antonin Artaud, among others, to an entire generation of artists and thinkers in Santiago.

104 R. Kay, 'On Photography, Time Split in Two' (trans. Osvaldo de la Torre), *Art Margins*, vol.2,

no.3, 2013, p.128. Original Spanish in R. Kay, *Del espacio de acá, op. cit.*, pp.23–24.

105 F. Godoy Vega, 'Cuerpos que machan, cuerpos correcionales', *op. cit.*, p.115.

106 R. Kay, 'On Photography', *op. cit.*, p.127. Original Spanish in R. Kay, *Del espacio de acá, op. cit.*, p.23.

107 *Ibid.*

108 A. Jaar quoted in David Levi Strauss, 'A Sea of Griefs is not a Proscenium', in *Let There Be Light: The Rwanda Project, 1994–1998*, Barcelona: Actar, 1998, n.p. The same quote, from an interview with Rubén Gallo, appears in Steffen Hau, 'Rwanda', in Frank Wagner et al., *Alfredo Jaar, The way it is: An Aesthetics of Resistance*, Berlin: Neue Gesellschaft für Bildene Kunst, 2012, p.300.

109 Griselda Pollock, 'Not-Forgetting Africa: The Dialectics of Attention/Inattention, Seeing/Denying, and Knowing/Understanding in the Positioning of the Viewer by the Work of Alfredo Jaar', in Nicole Schweizer (ed.), *Alfredo Jaar: La Politique des Images*, Zurich: JRP Ringier, 2007, p.132.

110 R. Kay, 'On Photography', *op. cit.*, p.127. Original Spanish in R. Kay, *Del espacio de acá, op. cit.*, p.23.

111 R. Kay, 'Cuadros de Honor', in *Del espacio de acá, op. cit.*, p.33. Author's translation. The phrase *cuadro de honor* also means 'honour roll' in the sense of an academic accolade; this wordplay seems intentional.

112 *Ibid.*, p.34.

113 *Ibid.*

114 Lihn co-taught seminars on Arthur Rimbaud with Kay while both were on the DEH faculty housed within the Faculty of Physical Sciences and Mathematics at the Universidad de Chile. For recollections of Kay's teaching, see A. Valdés, 'A los pies de la letra: arte y escritura in Chile', *op. cit.*, pp.279–80, as well as Pablo Oyarzún in conversation with Federico Galende, in *Filtraciones I: Conversaciones sobre arte in Chile: de los 60s a los 80s*, Santiago: Cuarto Propio, 2007, p.234.

115 E. Lihn, 'Arte disidente en Chile: Eugenio Dittborn, por el ojo del rodillo' (1979), in *Textos sobre arte*, Santiago: Diego Portales, 2016, p.335. Emphasis in original. Author's translation. First published in the Mexican magazine *Vuelta*, this text was included in Lihn's self-published *Derechos de Autor*, which circulated in Santiago in 1981. As noted in the original publication and the photocopy in *Derechos de Autor*, it was based on remarks delivered as part of a conference at the conclusion of Dittborn's show at Época.

116 *Ibid.*, p.336. Internal quotation likely Dittborn.

117 *Ibid.*, p.337.

118 For sociohistorical context, see Christina D. Abreu, 'The Story of Benny "Kid" Paret: Cuban Boxers, the Cuban Revolution, and the U.S. Media, 1959–1962', *Journal of Sport History*, vol.38, no.1, Spring 2011, pp.95–113.

119 A.M. Risco, 'Disarmed and Equipped: Strategies and Poetics of the Image in Eugenio Dittborn's Airmail Paintings', *Afterall*, issue 29, Spring 2012, p.74, n.11. See also 'Signs of Travel: Conversations between Roberto Morino and Eugenio Dittborn', in *MAPA*, London: Institute of Contemporary Arts, 1993, pp.14 (English) and 90 (Spanish).

120 Luke 23:53 (New Oxford Annotated Bible, Revised Standard Edition). Dittborn's original Spanish reads 'y habiéndole descolgado, le envolvió en una sábana, y le colocó en un sepulcro abierto en peña [or pena] viva, en donde ninguno hasta entonces había sido sepultado (San Lucas, XXIII, 53–54)'.

121 This point is made in Kate Jenckes, *Witnessing Beyond the Human: Addressing the Alterity of the Other in Post-coup Chile and Argentina*, Albany: State University of New York Press, 2017, p.136. For a broader discussion of potential textual inversions to the biblical passage and visual repercussions in Dittborn's work, see also pp.xi–xii and 136–42.

122 E. Lihn, 'Arte disidente en Chile: Eugenio Dittborn, por el ojo del rodillo', *op. cit.*, p.341. Emphasis in original.

123 A. Valdés, 'Eugenio Dittborn: Final de pista', *Mensaje*, no.268, May 1978, p.226. Author's translation. It seems worth noting the resonances between Dittborn's concerns and the issues that animated the contemporaneous work of Pictures Generation artists such as Cindy Sherman and Richard Prince, working in New York City. For a canonical position, see Douglas Crimp, 'Pictures', *October*, vol.8, Spring 1979, pp.75–88.

124 A. Valdés, 'Eugenio Dittborn: Final de pista', *op. cit.*, p.227. According to Valdés, Dittborn's works 'cannot be understood as separate from the works of those who, from a specific social situation, try to explain these phenomena'.

125 R. Kay, 'Cuadros de Honor', *op. cit.*, p.34. Emphasis in original.

126 See photo documentation of Jaar's panel for Mirna's response to the question of whether or not happiness is life's ideal.

127 Sara Ahmed, *The Promise of Happiness*, Durham, NC: Duke University Press, 2010, p.200.

128 *Ibid.*, p.218.

129 A. Jaar, in '"I need to understand the world before acting in the world"', *op. cit.*, pp.67–69.

130 Jeffrey M. Puryear, *Thinking Politics: Intellectuals and Democracy in Chile, 1973–1988*, Baltimore: Johns Hopkins University Press, 1994, p.52, and internal quotation from Heraldo Muñoz, p.53. On the internal responses to the dictatorship from a range of positions, see also S.J. Stern, *Battling for Hearts and Minds*, *op. cit.*, pp.196–217.

131 J.M. Puryear, *Thinking Politics*, *op. cit.*, p.58. Puryear details a particular example where CIEPLAN, using hard data analysis, showed that the Consumer Price Index had been manipulated by the government; CIEPLAN ultimately mounted an effective and powerful critique because its analysis was data driven. 'Science could speak when politics could not' (p.59).

132 A related point is made by Jacqueline Barnitz and Patrick Frank in a brief discussion of Jaar's work: 'Jaar's use of what appeared to be an empirical system of inquiry to obtain his answers made government interference virtually impossible, since there would have been no logical ground on which to object.' J. Barnitz and P. Frank, *Twentieth Century Art of Latin America*, Austin: University of Texas Press, 2015, p.313.

133 A. Valdés, 'Missing Chile: Far South. Far. Very Far', in F. Wagner et al., *Alfredo Jaar, The way it is*, *op. cit.*, p.183.

134 Related works that make use of similar – if not identical – imagery were published alongside Iván S. Jorol's article 'Stress' in the May 1979 issue of the men's magazine *Bravo*, at that time edited by Mario Fonseca. In addition to editing the magazine, Fonseca also published Kay's *Del espacio de acá*, Raúl Zurita's *Purgatorio* and ran a PR firm, MFV Limited, that sponsored Jaar's show at CAL. Jaar's imagery is credited to the artist, though as illustration rather than as an artwork. One of these images of Jaar was also used as an advertisement for his show, see *Revista cal 4* (1979), p.31. For context and full facsimiles of the four issues of *cal*, see Niki Raveau (ed.), *Revista cal, una historia*, Cociña, Chile: Soria Editores, 2013.

135 Jaar's degraded image resonates in a provocative way with his initial proposal for his CAL show, which was rejected by Nelly Richard and others running CAL's exhibition programme. Jaar had proposed to simply destroy the gallery interior, removing walls and fixtures, and leaving the place a ruin. Details of this unrealised intervention shared by Jaar in conversation with the author in New York on 21 October 2022.

136 R. Kay, 'On Photography', *op. cit.*, p.125. Original Spanish in R. Kay, *Del espacio de acá*, *op. cit.*, p.21.

137 For circulation and readership estimates, see S.J. Stern, *Battling for Hearts and Minds*, *op. cit.*, pp.158 and 299.

138 N. Fernández, *The Twilight Zone*, *op. cit.*, p.172.

139 For a summary of the Lonquén affair, see S.J. Stern, *Battling for Hearts and Minds*, *op. cit.*, pp.156–67; for a discussion attentive to the photographs of the kilns and related media coverage, see Á. Donoso Macaya, *The Insubordination of Photography*, *op. cit.*, pp.81–120.

140 S.J. Stern, *Battling for Hearts and Minds*, *op. cit.*, p.299.

141 'Lonquén: Hacia la recuperación del alma nacional', *Mensaje*, no.281, August 1979, p.428.

142 *Ibid.*

143 'Ante la oposición hay un actitud cobarde y cómoda: *callar*. Hay un tiempo de callar, pero también un tiempo de hablar, *un deber de hablar.*' Quoted in *ibid.*, p.430. Emphasis in original. Author's translation. Hurtado is one of only two Chileans to have been canonised by the Catholic Church, in 2005 by Pope Benedict XVI; Chile's other saint is Teresa de Jesús de Los Andes, who was canonised by Pope John Paul II in 1993. For his position on a 'social Catholicism', see Hurtado, 'Is Chile a Catholic Country' (1941), excerpted in Elizabeth Quay Huchinson, Thomas Miller Klubock, Mara B. Milanich and Peter Winn (ed.), *The Chile Reader: History, Culture, Politics*, Durham, NC: Duke University Press, 2013, pp.284–88.

144 It is worth noting that the military regime's consistent use of 9/11, or even just the 11 of a month for important political actions, mirrors – as triumph – Jaar's repeated usage of the number 11 on calendars and in notebooks in the aftermath of the coup, where repetition via either writing or the process of Letraset transfer became a way of working through trauma.

145 Jaime Guzmán, 'Protected Democracy and the 1980 Constitution' (1980, trans. Ryan Judge), excerpted in E. Quay Huchinson, T. Miller Klubock, M.B. Milanich and P. Winn (ed.), *The Chile Reader: History, Culture*, *op. cit.*, p.470.

146 *Ibid.*, p.471.

147 *Ibid.*, p.472.

148 *Ibid.*, p.473.

149 S.J. Stern, *Battling for Hearts and Minds, op. cit.*, p.179.

150 Details drawn from *ibid.*, pp.188–89.

151 'La Universidad Exige Libertad: Entrevista a Enrique D'Etigny', *APSI*, no.75, June 1980, p.5.

152 'Control was not applied evenly or with the same rigidity to every sector of cultural activity. Perhaps art was less victimized or effaced by the effects of censorship. The refined game of signs used by the avanzada to *divert social communication*, only confirmed its minority status. The administration was not too threatened by this offensive taken in art, since it was marginal to the other creative forms, like theatre or folklore, which are capable of bringing about a greater ideological consensus or popular unity.' N. Richard, *Margins and Institutions, op. cit.*, p.23. Emphasis in the original. Perhaps the most telling example of this is the firebombing by the DINA of the Paulina Waugh Art Gallery in Santiago in January 1977, which destroyed the gallery and its show of *arpilleras*. On the history of *arpilleras*, see Jacqueline Adams, *Art Against Dictatorship: Making and Exporting 'Arpilleras' Under Pinochet*, Austin: University of Texas Press, 2013; Marjorie Agosín, *Tapestries of Hope, Threads of Love: The 'Arpillera' Movement in Chile*, Lanham, MD: Rowman and Littlefield, 2008; as well as Julia Bryan-Wilson, *Fray: Art + Textile Politics*, Chicago: University of Chicago Press, 2017, pp.143–78.

153 A. Valdés, 'A los pies de la letra: arte y escritura in Chile', *op. cit.*, p.279.

154 For a brief discussion, see F. Godoy Vega, 'Cuerpos que machan, cuerpos correcionales', *op. cit.*, pp.107–09.

155 A. Valdés, 'An Open Work — A Non-Stop Record', *op. cit.*, n.p.

156 For a recent analysis of artistic practice in relation to the concept of the counterenvironment, which also draws on McLuhan's engagement with Henri Bergson's *Laughter*, see Kenneth R. Allen, 'Marshall McLuhan and the Counterenvironment: "The Medium is the Massage"', *Art Journal*, vol.73, no.4, 2014, pp.22–45.

157 A. Valdés, 'An Open Work — A Non-Stop Record', *op. cit.*, n.p.

158 The list includes dots at irregular intervals; it is unclear what these markings may have meant at the time.

159 For chronology, see Cecilia Vicuña, 'Performing Memory: An Autobiography' (trans. Rose Acalá), in R. Acalá (ed.), *Spit Temple: The Selected Performances of Cecilia Vicuña*, Brooklyn: Ugly Duckling Press, 2012. Vicuña notes her travel to the UK via Senegal (p.68) and her arrival in Colombia (p.77).

160 Jaar shared his recollection of having sent Vicuña a copy by mail in a phone interview with the author, 25 November 2019. Vicuña, for her part, remembered never having received the text in a Zoom interview with the author, 17 September 2021. Both confirmed that their first meeting was in upstate New York, at Art Awareness in Lexington, where they participated in a group exhibition in 1984.

161 Vicuña participated in a coordinated action related to *Para no morir de hambre en el arte* (*Not to Die of Hunger in Art*) in September 1979 while in Bogotá, titled *Un vaso de leche* (*A Glass of Milk*), as well as a later work once she moved to New York. Jaar was involved in the video documentation of *Ay, Sudamerica!* in July 1981. For Jaar's participation, see J. Dubs, *Making a Scene, op. cit.*, p.96. On Vicuña's relationship to the above work, see R. Neustadt, *CADA día, op. cit.*, pp.27–30.

162 'I decided to make a film asking the people of Bogotá, "What is poetry to you?" I formed a cooperative with a group of friends and went out into the street to film. It took me nearly twenty years to get enough funding to finish it.' C. Vicuña, 'Performing Memory', *op. cit.*, p.83. It is beyond the scope of the present discussion to attend to the full complexity of Vicuña's practice. For a recent survey of her work, see Miguel Lopez (ed.), *Cecilia Vicuña: Seehearing the Enlightened Future*, Mexico City: Museo Universitario Arte Contemporánio, UNAM, 2020; for a discussion focussed on her fibre art and quipus, see J. Bryan-Wilson, *Fray: Art + Textile Politics, op. cit.*, pp.107–43.

163 This and other details in the account that follows were provided by Vicuña in a Zoom conversation with the author, 17 September 2021.

164 Vicuña's impossible desire to call everyone in the directory to listen to them, particularly at a moment of such political possibility, is echoed in Macarena Gómez-Barris's claim that 'leading up to and during Allende's presidency, national consciousness was in a period of heteroglossia,

opening up to multiplicity not just within the
economic realm of socialism as "the better
alternative" (as a binary view of the period might
have it), but also within the arts, music, and
theatre, producing an expanded view of the
possible'. M. Gómez-Barris, *Where Memory Dwells:
Culture and State Violence in Chile*, Berkeley:
University of California Press, 2009, pp.79 and 101.
For a history that captures some of the textures
and tensions of this moment of potentiality, see
Patrick Barr-Melej, *Psychedelic Chile: Youth,
Counterculture, and Politics on the Road to
Socialism and Dictatorship*, Chapel Hill, NC:
University of North Carolina Press, 2017.

165 Esteban Monejo, *The Autobiography of a
Runaway Slave* (1966, ed. Miguel Barnet, trans.
Jocasta Innes) New York: Pantheon Books, 1968.

166 C. Vicuña, *Saborami*, Oakland, CA: Chain Links
Press, 2011, p.63. Originally published in 1973 by
Beau Geste Press.

167 *Ibid.*, p.65. A few documentary photos of the
original installation were taken and can be found,
along with two brief discussions of the historical
circumstances of Vicuña's work, as part of the
exhibition catalogue documenting the work's
reinstallation in 2007. See *Cecilia Vicuña: Otoño/
Autumn*, Santiago: Museo Nacional de Bellas
Artes, 2007.

168 On Antúnez's pronouncement, see C. Vicuña,
Saborami, op. cit., p.65.

169 The artist described meeting the members of the
group while travelling — Vicuña's cousin was
dating the CADA artist Juan Castillo — and that
they discussed their admiration for this early work
at Lotty Rosenfeld's house. C. Vicuña in a Zoom
conversation with the author, 17 September 2021.

170 For a detailed description of the actions
undertaken in *Not to Die of Hunger in Art* and
Scene Inversion, see Colectivo Acciones de Arte,
'para no morir de hambre en el arte,' *op. cit.*,
pp.22–24; and for a retrospective accounting, see
R. Neustadt, *CADA día, op. cit.*, pp.25–32. For
a critical analysis of CADA that would have been
accessible to Jaar at the time, see N. Richard,
Una mirada sobre el arte en Chile, op. cit., pp.63–81.

171 C. Vicuña, *Saborami, op. cit.*, pp.66–67. For
a more recent discussion around this work, see
J. Bryan-Wilson, 'Awareness of Awareness:
A Conversation with Cecilia Vicuña', in *About to
Happen: Cecilia Vicuña*, Catskill, NY: Siglio Press,
2017, pp.112–14.

172 'In the case of Skoghall, I was shocked to discover
that a community could exist for thirty years
without any visible cultural or exhibition space.
How do you represent the absence of this space
for culture in an entire community? I found it hard
to believe that people could live without the
intellectual and critical stimulus that visual art can
provide — to question, to speculate, and to search.
It blew my mind. I sought a spectacular way
to deal with this lack. I created an exhibition space
for twenty-four hours and then burned it away.
I wanted to offer a glimpse of what contemporary
art is and what it can do in a community. Then
by "disappearing" it in such a spectacular way, I
hoped to reveal its absence.' A. Jaar, in P.C. Phillips
and A. Jaar, 'The Aesthetics of Witnessing', *op. cit.*,
pp.25–26. Jaar discussed the act of destruction
undertaken in *Skoghall Konsthall* in relation to his
early unrealised proposal to destroy CAL's
exhibition space in 1979 in a Zoom conversation
with the author, 30 January 2023.

173 For a clear summary of this intellectual connection
and its role within Chile, see Jaar's discussion in
'"I need to understand the world before acting
in the world"', *op. cit.*, p.75. Jaar described his reading
habits circa 1980 and use of the family encyclopaedia
to look up Gramsci in a telephone conversation
with the author on 25 November 2019. Gramsci
and Pasolini remain of signal importance to the
artist, who produced a series of films in homage
to both figures as part of *The Gramsci Trilogy*
(2005). Jaar has also self-published a small edition
of Pasolini's 'The Ashes of Gramsci' as part of
a series of limited-run books on writings of signal
importance to the artist, which also includes
similar volumes dedicated to single texts by John
Cage, Jean-Luc Godard and Erri De Luca.

174 Pier Paolo Pasolini, 'The Ashes of Gramsci', in
The Selected Poetry of Pier Paolo Pasolini (ed. and
trans. Stephen Sartarelli), Chicago: University
of Chicago Press, 2014, p.175.

175 See Wallace P. Sillanpoa, 'Pasolini's Gramsci',
MLN: Modern Language Notes, vol.96, no.1,
January 1981, p.126. My thanks to Ara Merjian
for this reference and for help and thoughts on
a variety of matters, Pasolini-related and otherwise.
For a wide-ranging analysis of Pasolini's complex
relationship to the visual arts of his moment, see
A. Merjian, *Against the Avant-Garde: Pier Paolo
Pasolini, Contemporary Art, and Neocapitalism*,
Chicago: University of Chicago Press, 2020.

176 P.P. Pasolini, 'The Ashes of Gramsci', *op. cit.*, p.187.

177 Maurizio Viano, 'The Left According to The Ashes of Gramsci', *Social Text*, no.18, Winter 1987, p.56.

178 A. Jaar, in '"I need to understand the world before acting in the world"', *op. cit.*, p.75.

179 Antonio Gramsci, *Prison Notebooks, Volume I* (ed. Joseph A. Buttigieg), New York: Columbia University Press, 2011, p.172. See also Joseph Buttigieg's discussion of Gramsci's use of this famous phrase, which Gramsci attributed to Romain Rolland, and its earlier use by Jacob Burckhardt. J. Buttigieg, 'Notes to the Text', in *ibid.*, pp.474–75.

180 Jaime Massardo, *Gramsci en Chile: Apuntes para e l estudio crítico de una experiencia de difusión cultural*, Santiago: LOM Ediciones, 2012, pp.53–56.

181 Tomas Valdivia, 'Antonio Gramsci y el Marxismo: Otra forma de concebir la política', *Mensaje*, no.277, March/April 1979, p.143. Author's translation. On the importance of these texts for the general reception of Gramsci, see J. Massardo, *Gramsci en Chile, op. cit.*, pp.59–61.

182 For a useful analysis written around this time — if not in this context — see Chantal Mouffe, 'Hegemony and Ideology in Gramsci', in *Gramsci and Marxist Theory*, London: Routledge, 1979, pp.180–85. Mouffe explains that a hegemonic class is 'a class which has been able to articulate the interests of other social groups to its own by means of ideological struggle' (p.181). Mouffe has also written on Jaar, contextualising his work in relation to Gramscian conceptions of hegemony, asserting that 'Jaar's work provides one of the best examples of an aesthetics of resistance informed by the hegemonic strategy of war of position'. See C. Mouffe, 'Alfredo Jaar: The Artist as Organic Intellectual', in F. Wagner et al., *Alfredo Jaar, The way it is, op. cit.*, p.273.

183 T. Valdivia, 'Antonio Gramsci y el Marxismo', *op. cit.*, p.143.

184 Valdivia quotes Gramsci on the relationship between hegemony and pedagogy in *ibid.*, p.144. For a useful summary of Gramsci's views and the state of Marxist politics and theory circa 1900, see Ernesto Laclau, 'Gramsci', in Simon Critchley and William R. Schroeder (ed.), *A Companion to Continental Philosophy*, Malden, MA: Blackwell Publishers, 1999, pp.461–68.

185 T. Valdivia, 'Gramsci y la cultura', *Mensaje*, no.285, December 1979, p.830. Author's translation.

186 *Ibid.*, p.835.

187 *Ibid.*, p.836.

188 *Ibid.*, p.835. For an extended discussion of the role of the intellectual, see A. Gramsci, *Prison Notebooks, Volume II, op. cit.*, pp.199–210. As Gramsci writes: 'The intellectuals have the function of organizing the social hegemony of a group and that group's domination of the state' (pp.200–01).

189 I take this to be the drift of Sara Ahmed's point when she writes: 'The freedom to be unhappy might provide the basis for a new political ontology, which, in not taking happiness as an agreed endpoint for human action, would be able to ask about the point of action.' S. Ahmed, *The Promise of Happiness, op. cit.*, pp.195–96.

190 Raymond Williams, 'Base and Superstructure in Marxist Cultural Theory' (1973), in *Problems in Materialism and Culture*, London: Verso, 1980, p.39. Emphasis added.

191 *Ibid.*, p.47.

192 A. Jaar, in G. Goldberg, 'Alfredo Jaar: Las siete estaciones de una "obra abierta"', *op. cit.*, p.9. It's worth noting that both Jaar's and Williams's formulations share much with the classic description of the social history of art in T.J. Clark, *Image of the People: Gustave Courbet and the 1848 Revolution*, London: Thames & Hudson, 1973, pp.9–20.

193 A. Gramsci, *Prison Notebooks, Volume II, op. cit.*, p.215.

194 For reviews that mention the work, see Waldemar Sommer, 'Los Resultados De un Concurso', *El Mercurio*, 25 November 1979; and Ricardo Bindis, 'Concurso de la Colocadora', *La Tercera*, 2 December 1979, p.24.

195 Reading these lines, compressed as they are, it's hard to not see a buried reference to Eugenio Dittborn's influential exhibition at the Galería Época in May 1976, 'delachilenapintura, historia'. For a wide-ranging discussion that often touches on this exhibition, see Dittborn in conversation with F. Galende, in *Filtraciones I, op. cit.*, pp.139–56.

196 Photographs of the work are ambiguous in relation to the form of the protruding smile and frown, and whether it could have been a voting box. In an email to the author on 29 July 2021, Jaar confirmed that the extension was purely formal and offered no interactive component, even as he acknowledged that 'it is the ghost' of the later voting boxes used in *Studies on Happiness*. For a photo that shows

the relative protrusion in some detail (or at least with a suitably raking shadow), see the exhibition pamphlet for the Quinto Concurso de la Colocadora Nacional de Valores held at the Museo Nacional de Bellas Artes, Santiago in 1979.

197 Raúl Zurita, 'Preface: Some Words for this Edition', in *Purgatory: A Bilingual Edition* (1979, trans. Anna Deeny), Berkeley: University of California Press, 2009, p.xii.

198 R. Zurita, *Purgatory, op. cit.*, pp.2–3.

199 *Ibid.*, pp.8–9 and 11.

200 *Ibid.*, pp.90–95.

201 *Ibid.*, pp.56–57.

202 Zurita shared his recollections of his time before Jaar's camera in email correspondence with the author, 29 July 2022. Author's translation.

203 Transcription taken from video footage held in Jaar's studio archives, though this poem appears elsewhere. The exact word choice used by Zurita is published in R. Zurita, '"Deserts" from "Purgatorio"', *Latin American Literary Review*, vol.11, no.23, Fall–Winter 1983, p.86. I have followed Anna Deeny Morales's 2019 translation, with minor alterations to tense, as it relates to this poem's later publication in Zurita's personal anthology *Tu Vida Rompiéndose* (2015), where it appears twice: as 'Poema Final' (Last Poem, p.590), and, in slightly altered form, in the context of *Anteparadise* (p.119). For Deeny Morales's translation, see https://www.poetryinternational. com/en/poets-poems/poems/poem/103-29802_ FINAL-POEM (accessed on 26 January 2023).

204 Zurita confirmed that this was the first time he had read this poem in public in email correspondence with the author, 1 August 2022.

205 R. Zurita, 'Introductory Note', in *Anteparadise: A Bilingual Edition* (1982, trans. Jack Schmitt), Berkeley: University of California Press, 1986, p.v.

206 This is the title of the final poem in *Anteparadise*. 'Esplendor en el viento' in the original. See *ibid.*, p.204–5.

207 *Ibid.*

208 R. Zurita, 'Introductory Note', in *ibid.*, p.v. This is a forceful articulation of Sara Ahmed's point that 'to suffer can mean to feel your disagreement with what has been judged good'. S. Ahmed, *The Promise of Happiness, op. cit.*, p.210.

209 R. Zurita, email correspondence with the author, 3 August 2022. Author's translation.

210 *Ibid.*

Edward A. Vazquez is Associate Professor in the Department of the History of Art and Architecture at Middlebury College in Vermont, where he has taught since 2009. He is the author of *Aspects: Fred Sandback's Sculpture* (2017) and his essays have appeared in *Art Journal* and *RES*, among other publications. His research and writing have been supported by the American Council of Learned Societies; the Graham Foundation for Advanced Studies in the Fine Arts; and the Center for Advanced Study in the Visual Arts at the National Gallery of Art, Washington DC.

Gordon Matta-Clark:
CONICAL INTERSECT
by Bruce Jenkins

Jeff Wall:
PICTURE FOR WOMEN
by David Campany

Jeff Koons:
ONE BALL TOTAL
EQUILIBRIUM TANK
by Michael Archer

Richard Hamilton:
SWINGEING
LONDON 67 (F)
by Andrew Wilson

Martha Rosler:
THE BOWERY
IN TWO INADEQUATE
DESCRIPTIVE SYSTEMS
by Steve Edwards

Dan Graham:
ROCK MY RELIGION
by Kodwo Eshun

Yayoi Kusama:
INFINITY MIRROR
ROOM – PHALLI'S FIELD
by Jo Applin

Michael Asher:
KUNSTHALLE BERN, 1992
by Anne Rorimer

Sanja Iveković:
TRIANGLE
by Ruth Noack

Hélio Oiticica and Neville D'Almeida:
BLOCK-EXPERIMENTS IN
COSMOCOCA – PROGRAM
IN PROGRESS
by Sabeth Buchmann and Max Jorge Hinderer Cruz

General Idea:
IMAGEVIRUS
by Gregg Bordowitz

Philip Guston:
THE STUDIO
by Craig Burnett

Thomas Hirschhorn:
DELEUZE MONUMENT
by Anna Dezeuze

Mike Kelley:
EDUCATIONAL COMPLEX
by John Miller

Lee Friedlander:
THE LITTLE SCREENS
by Saul Anton

Agnes Martin:
NIGHT SEA
by Suzanne Hudson

Sturtevant:
WARHOL'S MARILYN
by Patricia Lee

Sigmar Polke:
GIRLFRIENDS
by Stefan Gronert

David Hammons:
BLIZ-AARD BALL SALE
by Elena Filipovic

Walker Evans:
KITCHEN CORNER
by Olivier Richon

Sharon Lockhart:
PINE FLAT
by Howard Singerman

Mark Leckey:
FIORUCCI MADE ME
HARDCORE
by Mitch Speed

Beverly Buchanan:
MARSH RUINS
by Amelia Groom

Pierre Huyghe:
UNTITLED (HUMAN MASK)
by Mark Lewis

Helen Chadwick:
THE OVAL COURT
by Marina Warner

Donald Rodney:
AUTOICON
by Richard Birkett

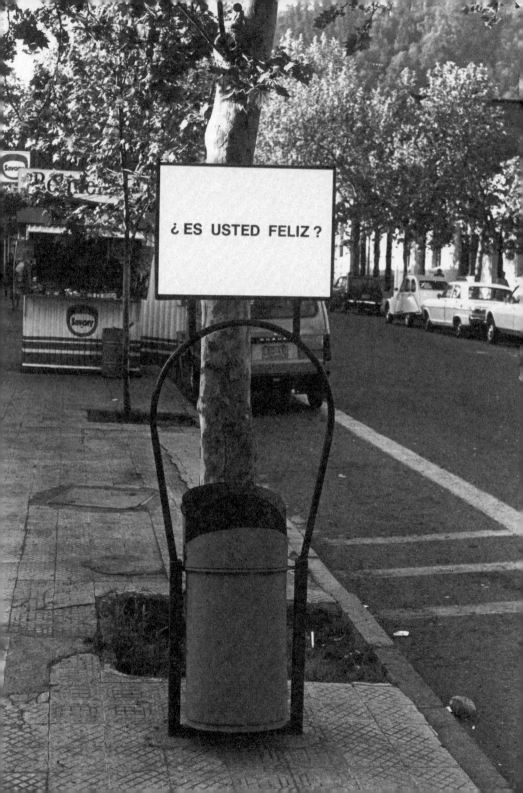